Roger Fenton

PASHA AND BAYADÈRE

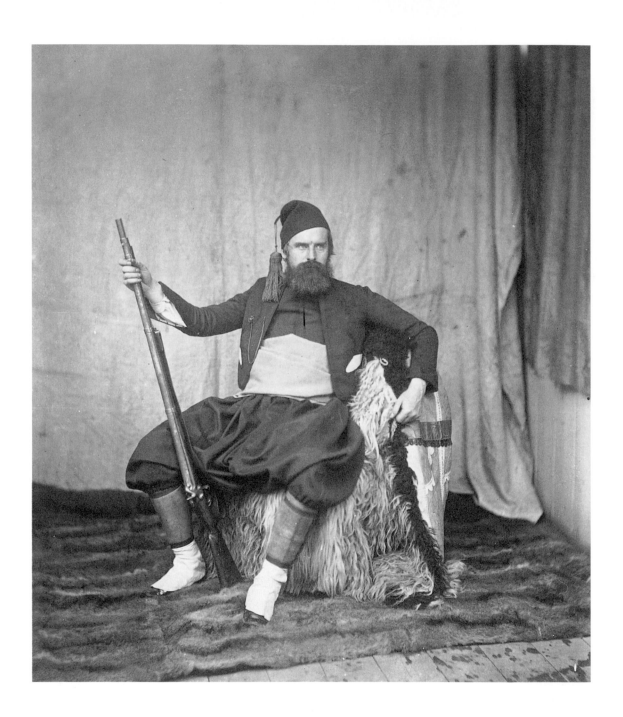

Roger Fenton

Pasha and Bayadère

Gordon Baldwin

**GETTY MUSEUM
STUDIES ON ART**

Los Angeles

Christopher Hudson, *Publisher*
Mark Greenberg, *Managing Editor*

William Peterson, *Editor*
Eileen Delson, *Designer*
Jeffrey Cohen, *Series Designer*
Stacy Miyagawa, *Production Coordinator*
Ellen Rosenbery, *Photographer*

© 1996 The J. Paul Getty Museum
17985 Pacific Coast Highway
Malibu, California 90265-5799

Mailing address:
P.O. Box 2112
Santa Monica, California 90407-2112

Library of Congress
Cataloging-in-Publications Data

Baldwin, Gordon.
 Roger Fenton : Pasha and Bayadère / [Gordon
Baldwin].
 p. cm.
 (Getty Museum studies on art)
 ISBN 0-89236-367-3
 1. Photography, Artistic. 2. Portrait photog-
raphy. 3. Fenton, Roger, 1819–1869.
 I. Fenton, Roger, 1819–1869. II. Title. III. Series.
 TR652.B35 1996
 770'.092-DC20 96-1755
 CIP

Cover:
Roger Fenton (British, 1819–1869).
Pasha and Bayadère, 1858 [detail].
Albumen print, 45 × 36.3 cm (17 $^{11}/_{16}$ × 14 $^{1}/_{4}$ in.).
Los Angeles, J. Paul Getty Museum (84.XP.219.32).

Frontispiece:
Roger Fenton.
Self-Portrait in Zouave Uniform, 1855.
Albumen print, 17.3 × 15.3 cm (6 $^{13}/_{16}$ × 6 in.).
Los Angeles, J. Paul Getty Museum (84.XM.1028.17).

All works of art are reproduced (and photographs
provided) courtesy of the owners unless otherwise
indicated.

Typography by G & S Typesetters, Inc.,
Austin, Texas
Printed by C & C Offset Printing Co., Ltd.,
Hong Kong

CONTENTS

Final page folds out,
providing a reference color plate of
Pasha and Bayadère

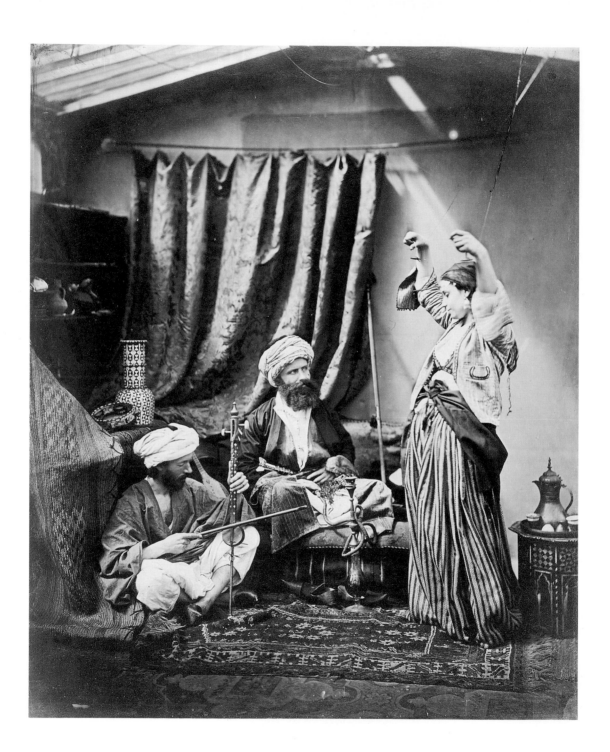

Through Victorian Eyes:
An Inventory of a Photograph

If an average viewer had closely examined the picture on the facing page [FIGURE I *and* FOLDOUT] when it was first exhibited to the London public in January of 1859 at the sixth annual exhibition of the Photographic Society, and had both time and patience to make a detailed narrative description of its contents, perhaps as part of that Victorian compulsion to categorize and classify, the survey might have read something like that which follows here. (We will assume that our imaginary viewer had an education, a keen eye or a pocket glass, a certain knowledge of the contemporary world, an unrestrained freedom of expression, and few distractions from other people in the gallery, which in typical nineteenth-century fashion was crowded with pictures, hung at least three deep, and more likely five.[1] We must also assume that the picture was hung at something like eye level.) Perhaps it's a rainy Tuesday morning and there is no one else on the premises but a ticket taker. As our viewer has chosen to come in the morning, he or she has a certain leisure and can afford both the somewhat higher price that is charged during the day, when visibility is usually better than during the gaslit evenings, and a program listing the titles of the pictures and their makers. On fishing a pencil from reticule or pocket, and if a woman, pushing her voluminous skirts to the side so that she can get as close to the glass as possible, our viewer begins:

"The picture, obviously a photograph, is an upright rectangle of the usual reddish browns and creams. At first glance it shows three figures closely grouped together in an interior. In the center there is a bearded fellow sitting on a low divan and gazing alertly and appreciatively upward to the right, toward an exotically dressed woman, who is evidently dancing, as her hands are held high over her head and there are finger cymbals dangling from their tips. No lady should ever be seen with her elbows above her shoulders. This woman must be common. She is seen from the side, illumined by a great diagonal torrent of light that slashes down from a simple skylight at the upper left corner of the frame. Her figure undulates, her midsection is canted forward and half-turned toward me,

while her head and upper body twist back toward the seated man, though her eyes are modestly downcast, seemingly directed at the floor, perhaps toward the foot of the other man, who sits cross-legged on the carpet. From the odd-looking stringed instrument he bows, he is clearly a musician playing an accompaniment to her dance. This is all very charming: something like Scheherazade entertaining her sultan, though perhaps not quite so splendid as I had imagined. Still, there is a quality of reality here that one doesn't get in a painting. What does the catalogue say? Here it is, number 43, *Pasha and Bayadère* by Roger Fenton.[2] Ah yes, Fenton; he's the one who went out to the Crimea a few years ago and made pictures of that terrible war. Can this be a scene he photographed there? Did he go among the Turks? How curious and informative. I must look more closely.

"This dancing girl, this bayadère, is the center of it all. She commands the scene, from the forcefulness of her standing position and from the energy of her apparent motion. Among such people a woman covers her hair. Her earlobe peeps from beneath her patterned head scarf and is decorated with an elaborate earring that looks like a cascade of tiny balls depending from a bell. Across her forehead dangles a row of coins. Whatever for? Although it's rather pretty, bride's price or some such? The tiny buttons along the close-fitting sleeves of her finely striped and simply embroidered jacket are undone, so that with the upward thrust of her arms, the sleeves slip back, dragging with them the sleeves of her white cotton blouse and exposing her naked forearms. The minuscule buttons running down the front edges of her jacket are also unfastened, revealing the line of her throat and the swelling of her bosom beneath the thin cotton of her blouse, which is held close to her body by a low-cut bodice closed by a single clasp. Around her hips is slung a dark colored shawl, tied up at her waist.[3] What a temptress she is! The stripes of her heavy, divided skirt, swirling up from the floor, emphasize the energy of her dance. Her feet are hidden, perhaps even bare on the strongly patterned rug. She's dancing for the delectation of this pasha whose eyes so eagerly follow her. And what sort of person is he? Is he her master? Does he own her? I suppose she must be a concubine or some sort of harem girl. I wonder how she likes that?

"Although he sits firmly upright, he sits cross-legged like the musician, so his garments are hard to distinguish clearly, but they appear to be composed of three layers. He has an outer robe of dark color with what seem like shawl-shaped

lapels, a faintly striped inner robe, perhaps of polished cotton, but lined in a lighter-colored fabric, and beneath it an innermost shirt or robe, white with a legion of tightly spaced tiny buttons down the front. Not all of these are fastened—it must require great patience to do them all up. And what's this? In an unbuttoned gap a patch of pale skin on his stomach is visible. Most unseemly! Obviously these are a rather loose and indolent people. His hands rest lightly in his lap, one lying along a sash tied over his inner robe. The fringe of the sash falls into his lap, and out of it protrudes what appears to be the hilt of a jeweled dagger. His other hand touches the mouthpiece at the end of the long flexible stem that snakes up from the water pipe sitting on the floor next to his pointed slippers. I suppose that pipe is for tobacco, or worse. On his head a turban of lightly checked material is wrapped around a dark center. His dark beard and moustache are so wavy and luxuriant that his mouth is wholly obscured save for a fragment of his lower lip, leaving only the intense concentration of his upturned eyes to give an idea of his mood. He clearly relishes this dancing girl.

"By comparison to him the musician is more simply dressed. On his head, which is lightly bent to his instrument, is a plain white turban, again wound around a dark center. A slight man, he wears a loose, lightly figured robe with its sleeves folded back, perhaps for ease in playing. As he is seated, its length is bunched about his waist, but it gapes below the neck, exposing a corner of white undershirt and—shocking indeed—a somewhat hirsute chest! Loose white trousers do not completely cover his shins, and he has pointed shoes on his feet. He is bearded and wears a band on the ring finger of his left hand. He does not interact with the other two but is apparently intent on his music. What must that music sound like? Some sort of gypsy air?

"Besides the fabrics of their clothing, the space they inhabit is furnished with a variety of other stuffs. The cushions of the divan are covered in what seems damask with piped, striped edges, and it has an underskirt of wide stripes. Behind the musician's right shoulder is a heavy woven rug, draped over something bulky. In back, beyond the low couch, a large drapery of heavily patterned brocade hangs from a somewhat bowed rod, inadequate for the weight of the curtain. And underneath the Oriental rug on the floor is another carpet which looks mechanically woven. How odd. That seems familiar. Isn't that British?

"The space is richly appointed with a quantity of objects. A tray with a coffeepot and delicate cups in their holders rests on one of those octagonal tables inlaid with diamond-shaped lozenges in mother of pearl. There's some sort of long segmented rod, upright next to the man on the divan. (If our visitor had traveled or read widely, he or she might have recognized this as a *chibouk*, a tobacco pipe of Turkish origin, characterized by having a very long stem, a mouthpiece usually of amber, and a bowl of wood or clay. A viewer this well-informed might also know that a name for the spike fiddle is *rabāba*.) Behind him is what looks to be a lute. On a ledge above the head of the musician are a tambourine and, upside down, an inlaid goblet drum. Above the ledge on shelves with scalloped edges is a group of pottery vessels, difficult to make out as their volumes are half lost in shadow. Beyond the brocade curtain that hangs in the back is an ordinary, nondescript wall, scored horizontally like masonry, but probably just painted plaster. Indeed, this pasha's palace is rather puzzling. I can't help noticing that the source of light overhead is a tented skylight. Clearly visible in the upper left corner and slightly visible in the upper right, this seems not altogether unlike the skylight arrangements that photographers have in their portrait studios here in London. Also, in that upper right corner there's something truly odd: what look to be two wires running down to the upheld wrists of the dancing woman, as if she were a marionette! Whatever are they for? Despite its considerable charm, what a curious picture this is."

Of course, the puppeteer manipulating the strings of the dancing woman is not above and beyond the proscenium formed by the edges of the photograph, but out in front of it, behind the camera. Displayed with this photograph in 1859 were others by Roger Fenton, the titles of which also denoted places in the Near East and the subjects of which were persons who dressed very differently from Europeans of the period, and who had assumed societally abnormal postures in surroundings filled with objects not commonly found in a London house in the 1850s. Their subjects were, in short, exotic, perhaps rather thrilling, and even occasionally somewhat erotic. As it was well known that Roger Fenton had returned from a photographic expedition to the Crimean War only three and a half years earlier,

this photograph and its fellows might be thought to have been made during the course of that trip. In that case, the *Pasha and the Bayadère* could be taken to provide a kind of truthful evidence about real life in the Near East.

The photograph is not, of course, anything quite so simple. Nor, for that matter, given Islamic cultural prohibitions, could such a scene of Turkish life have existed as a photograph. Nor, even if a photograph could have been made of an analogous scene, of a dancer entertaining a "pasha," would it have shown anything very much like what it does. Not only would the actual conditions have been different, but the length of exposure required by the photographic chemistry of the period would still have precluded any registration of action. The scene could only have been "staged." Artifice is more than a little present, and the work is not without its share of cultural biases.

This picture and the others of closely related subjects that Fenton made at about the same time have considerably confused viewers from the moment they were first exhibited,[4] and the effort of this book is to show why that is so, why this image is purely a work of art of its own time and place, why it came to be as it is, and finally, how perceptions about it have changed. Before tracing the genesis of the work in more detail, however, an explanation of how this print and its fellows survived into the present day and a sketch of the life of its maker, Roger Fenton, are in order to establish the context in which this picture was found and in which it was produced.

Fenton made fifty-one images of which there are surviving prints in the series that is called here the Orientalist suite because its general subject is the presentation of imagined scenes from domestic life in the Islamic world. These pictures were made, not in the part of the world they purport to represent, which Fenton had visited in 1855, but in Fenton's London studio in the summer of 1858. Three of them were exhibited in December of the same year in Edinburgh, then eight were shown in London in January of 1859, and a few more in Paris in April. None were shown by him thereafter.

This print of the *Pasha and Bayadère*, now in the collection of the J. Paul Getty Museum, was originally contained in one of three oversize folio albums, known after the color of their pages as the "grey" albums, from which the great majority of the surviving prints of Fenton's Orientalist images come. These

albums were dispersed at auction in England from 1978 to 1982. The auction house received the albums, lacking covers and perhaps partially disbound, in late 1977 from a descendent of a friend of Fenton's.[5] The albums contained a large number of the Orientalist pictures, many of which are not known in any other prints. It's possible that some of these images were considered artistic failures by Fenton, were printed only this once by him, were never exhibited, and consequently only survive because they were saved in the albums as a kind of record or as remembrances of the occasions on which they were made.

The albums might best be considered as scrapbooks in which Fenton or some member of his family assembled examples of his own work together with pictures by some of his contemporaries, including Gustave Le Gray, Camille Silvy, Oscar Rejlander, and Francis Bedford. Included were also a large number of carte-de-visite-size albumen prints. These are not mounted, as is customary, on individually cut cards, but are instead directly adhered to the album pages, indicating that they were acquired from their makers rather than from the sitters, though there is a possibility that some may have been made by Fenton himself. If so, they are his only known work in this format. The sitters for these cartes range from the famous to the unknown, although some can be presumed to be members of the Fenton family.[6] One might have expected Fenton to have used a higher quality of paper than the pages of this album, something similar to the paper he used for mounting photographs for sale. As scrapbooks, however, their assembly may have been casual, conceivably from studio remnants. Had a record been made of the pages in their original order with their contents, the albums would have been a valuable source for the study of Fenton's life and work.

Fenton's life was filled with an unusually wide variety of experiences. Born in 1819 at Crimble Hall near Heywood in Lancashire, in an area that is now on the northern outskirts of Manchester, Fenton was one of seven children, and the second surviving son of John Fenton (1791–1863) and his first wife Elizabeth Aipedaile. His father was a banker, a Liberal member of Parliament for the new seat of Rochdale, and a Justice of the Peace for the County of Lancashire and the West Riding of Yorkshire.[7] After the death of Fenton's mother in 1830 his father married again, this time to Hannah Owston, who bore him thirteen additional children. Roger Fenton was the grandson of Joseph Fenton (1765–1840), a gen-

erous and gregarious pioneering industrialist who had amassed a considerable fortune in banking and in cotton manufacturing. By the time of his death he had acquired significant landholdings with their attendant lordships of the manor.[8] Several of these properties were clustered together outside Rochdale at Bamford, flanking on the north and south an innovative cotton-processing mill which he had constructed at great cost. As Fenton's father apparently did not overmuch concern himself with the family businesses but rather paid attention to his political career and judiciary responsibilities, after the death of the grandfather in 1840 the management of the family bank and factories passed into the hands of Fenton's elder brother, a younger brother, and a nephew. Fenton himself apparently declined to enter any of the family enterprises, and after studying Latin, Greek, mathematics, and English at University College, London, he received a Master of Arts degree in 1840. His grandfather having died that year leaving a substantial sum, Fenton immediately enjoyed some income from what he inherited.[9]

Fenton was at this juncture an educated young man, relatively recently arrived in London from Lancashire, not an aristocrat or a member of the landed gentry, but a representative of the third generation of a rapidly swelling class that derived its money primarily from industry and commercial enterprise, not land. The most successful of this class were men like Lord Overstone, the patron of Julia Margaret Cameron, but Fenton's family cannot be considered to have risen as high as he.[10] Thus primed, Fenton might well have entered the professions, and at about this time he did in fact begin to study law, but shortly thereafter, somewhat surprisingly, he also began to learn to paint, becoming a pupil of the history painter Charles Lucy (1814–1873). Lucy had been trained in the Paris studio of another history painter, Paul Delaroche (1797–1856).[11] Painters better known than Lucy who were pupils of Delaroche include Jean-Léon Gérôme (1824–1904) and Charles-François Daubigny (1817–1878).

Exactly when Fenton first went to Paris to study painting, and with whom he studied there, has long been a matter of conjecture. Traditionally he has been placed in the populous studio of Delaroche, in part because it was where his teacher, Lucy, had studied, but also because of the presence there of three other young men, of nearly exactly the same age as Fenton, who were to abandon painting several years later and to become the foremost French photographers of

the next decade. Gustave Le Gray (1820–1882/3)[12] was certainly Delaroche's pupil between 1840 and 1843, as were Henri Le Secq (1818–1882) and Charles Nègre (1820–1880), who had started there a year earlier, in 1839, and would be the first to take up photography, around 1844. As Delaroche's studio was very large, Fenton may not have gotten to know all three at this period, although they were later to be friends, particularly Le Gray.

The difficulty with the idea that Fenton studied with Delaroche has been a matter of dates. If, as it has sometimes been stated, Fenton first went to Paris only in 1843 or thereafter, he could not have studied with Delaroche, since by July of that year the painter had disbanded his studio and removed to Rome, from which he did not return until 1845. However, the discovery that a passport for Fenton was issued on June 28, 1842, at the recommendation of Mr. Cunliffe, banker of Bucklebury, strongly suggests that Fenton may have gone to Paris for the first time a year earlier than was previously thought.[13] Passports at this period were not generally used by travelers except for members of the upper classes or those who may have had indefinite stays abroad in mind, and the documents seem to have been issued for immediate use. If Fenton arrived in Paris in the summer of 1842 he would have been able to become and remain a private pupil of Delaroche's for a year. Fenton's friend the French photography critic Ernest Lacan specifically stated in 1856 that Fenton had studied under Delaroche.[14] He was evidently not an official pupil of Delaroche or of any other painter connected to the École des Beaux-Arts as there are no records pertaining to him in the archives of that school.

By the end of the following summer, however, Fenton had returned to England to marry Grace Elizabeth Maynard, which he did in Yorkshire on August 29, 1843. Where they met, like much of Fenton's personal life, remains obscure, but one can speculate that a courtship by letters may have occurred. Judging by the tone of his letters to her from the Crimea, which are occasionally mildly humorous and permeated with a vein of devoted love, it was a happy marriage.[15] Soon thereafter they both went to Paris, where at least the second of their first two daughters was born in 1846. As Fenton presumably continued to study painting, it is tempting in the context of this book to assign him at this slightly later period to the studio of the history painter Charles Gleyre (1806–1874), who had more or less inherited Delaroche's studio, because of Gleyre's extensive travel in the Near East

in 1834 and 1835, which provided the subject matter of much of his early work. It is also just possible that Fenton was able to study informally with Delaroche during this second period although the painter did not resume teaching publicly. Fenton would have differed from the ordinary student of painting of the 1840s in that he was already married and had a private income. Not for him the garrets of Murger's Bohemia.

By 1848 Fenton and his family had returned to London and had moved into a newly built house at 2 Albert Terrace immediately adjacent to Primrose Hill Park on what was then the northern edge of London.[16] In the following three years he is mentioned frequently in the diary of the painter Ford Madox Brown, both as a student of Charles Lucy and in his own right.[17] Fenton was thus arguably trained in the studios of at least two well-known history painters, Delaroche or Gleyre, and Lucy, and had acquired at least a minimum competence as a painter. In each of the three years, 1849, 1850, and 1851, he exhibited a single canvas at the annual May exhibition of the Royal Academy. These paintings, like of all of the rest of his work in this medium, have now vanished. Judging by their titles they were genre pictures with a high degree of narrative content, and in this respect they bear some relation to Fenton's Orientalist photographs and were unlike nearly all of the rest of his photographic work.[18] The painting he exhibited in 1851, *There's music in his very steps as he comes up the stairs*, seems to have been the only one of the three to attract critical attention, and that not very laudatory. The reviewer for the *Art Journal* commented:

> The picture bearing this affected title is a study of a girl lying on a
> sofa, she wears a green quilted petticoat, which is admirably painted;
> the head is also highly successful, but the draperies and accessories,
> with their careful execution, precede the head in importance.[19]

Because Fenton was not attracting strongly positive notice as a painter it is perhaps not surprising that he may have wished to try his hand at photography. In any case, at about this time he was involved in several other significant projects.

First, during the year before, 1850, Fenton had been instrumental, along with the painter Thomas Seddon (1821–1856) and others, in the establishment of

the North London School of Drawing and Modelling, a school for the evening instruction of working men. Prince Albert was the patron of this establishment, which was founded with the hope that better draftsmanship would lead to better design in the production of manufactured goods. This was the beginning of Fenton's extended series of associations with the prince. At nearly the same time Fenton must have completed his studies in law, or finished sitting for the requisite number of dinners, as he was called to the bar in 1851.[20] With this prudent move he could both assure himself of an income beyond his inheritance and secure his place in society. It nevertheless suggests a hesitancy about the direction in which photography might take him, a wholly realistic attitude toward an uncharted medium that had only come into existence a dozen years before and that was still encumbered in England by Talbot's patent. This is not to say that Fenton was overly cautious; he consistently chose to accept challenges in the form of difficult and even dangerous photographic assignments.

Second, in the fall of 1851 he returned to Paris to study the activities of the first organized group of photographers, the Société Héliographique. By this time he had become seriously interested in photography, conceivably because of correspondence with Le Gray, Le Secq, or one of the other founding members of the Société, or perhaps because of the inclusion of photography in the Crystal Palace Exhibition that summer.[21] As an educated man involved in the arts, he would, of course, have been aware of it for far longer, but the exhibition may have been his first opportunity to see a substantial group of photographs gathered in one place.

It has been a matter of real speculation as to when Fenton became seriously involved with photography, but his first known photographs are dated February 1852, and that seems close to the time he took it up.[22] By that August he was sufficiently versed in using the waxed paper process for the production of negatives to write about it. From this time forward, he would continually work out refinements to existing technical procedures and recommend the improvements that he discovered to his fellow photographers. In other words, having found photography, Fenton plunged deep. As a man of a certain wealth, he had the resources to pursue what was not an inexpensive enterprise. One is tempted to say that he also had the time to do so, except that considering Fenton's prodigious expendi-

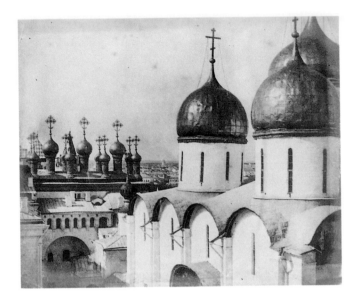

Figure 2
Roger Fenton.
From Ivanif [sic] *Tower,
Kremlin, Moscow*, Sep-
tember, 1852. Album-
enized salt print, 18.3 ×
21.3 cm (6³⁄₄ × 8³⁄₈ in.).
Los Angeles, J. Paul
Getty Museum.

tures of energy until at least 1862, leisure does not seem to have figured in his life. What he learned from the members of the Société Héliographique, the world's first formal photographic association, would have important British ramifications in the following two years.

Third, in the fall of 1852 he adventurously went to Russia with his friend, the engineer Charles Blacker Vignoles, to photograph a bridge that Vignoles, with great difficulty, was constructing across the Dnieper near Kiev.[23] While there Fenton also made an extensive series of what are currently thought to be the first photographs of Moscow [FIGURE 2]. His photograph of church roof-tops in the Kremlin is audacious in the way it translates onion domes into ornate chess pieces seen from board level. He compresses the architecture so that it completely fills the frame of the photograph, a technique he would continue to use. At about this time his first published photographs appeared in England—publication of photographs in this era meant simply the production of texts to accompany a specified group of photographs that had been fixed individually to mounts.[24]

Fourth, and perhaps most important, in 1853 he became one of the founders of the Photographic Society, which would ultimately become the Royal Photographic Society. (Some of his contemporaries felt that without him it would

not have come into being.) For its first three years he was its secretary—an honorary, unpaid position, but its chief operating executive. He was a constant member of its governing board, its longtime vice president, an indefatigable attendee and chairman of its meetings, and an active participant in all of its activities, including its exhibitions to which he consistently contributed his latest productions. The Photographic Society was not the only organization to which he belonged, although he devoted more attention to it than to his other member ships, which included the Society of Arts and the Arundel Society.[25] He would also join the Architectural Photographic Association when it came into being. The following year he made a series of photographs of Queen Victoria and her family, particularly of her children in five of the tableaux that the royal family regularly staged to celebrate birthdays and anniversaries.[26] He was also hired to document some of the collections of the British Museum, the first photographer ever to be employed for such a purpose.

The year 1855 made Fenton's photographic reputation. Armed with letters of introduction from Prince Albert, and sponsored by the Manchester publisher Thomas Agnew & Sons, Fenton left by steamer in February for the Crimea, where Britain, in alliance with France and the Ottoman Empire, was fighting an unpopular war against the Russians. Fenton remained there until the following June, making photographs of battle sites and back-up operations and portraits of soldiers and officers in what was the first large-scale photographic documentation of a war. As his even-tempered and sometimes humorous letters to Agnew and his family make clear, he worked under considerable hardship because of the chaos endemic to war and because the adverse climatic conditions made the manipulations of the photographic process he employed very difficult to accomplish.[27] He and the horse-drawn van that served as his darkroom—needed for the last-minute chemical manipulations essential to the wet-collodion process—were occasionally in real danger from enemy fire. Throughout this expedition he displayed admirable initiative, ingenuity, and patience, and he won a high degree of acceptance from seasoned soldiers and generals who wholeheartedly adopted him into their ranks. His assistant, Marcus Sparling, who drove the darkroom van and looked after the horses as well as aiding Fenton in preparing photographic plates and the like, and his servant, William, were less steady, and sometimes of no help

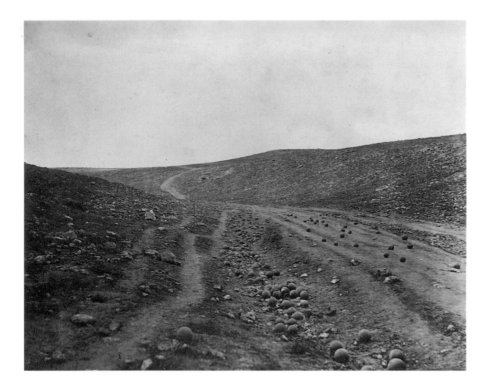

Figure 3
Roger Fenton.
*Valley of the Shadow of
Death*, April 23, 1855.
Salt print, 27.4 × 34.7
cm (10⅞ × 13¾ in.).
Los Angeles, J. Paul
Getty Museum.

at all due to overindulgence in alcohol. The three hundred and sixty or so images that Fenton produced on his glass-plate negatives encompass stark landscapes of battlefields, panoramas of distant military objectives, informal campsite studies of groups of enlisted men, and portraits of haggard generals. The Spartan eloquence of his barren landscape of a battlefield littered with cannon balls has rarely been equaled as an expression of the desolation of war [FIGURE 3].

His image of Field Marshall Lord Raglan, the commander in the field of the British forces [FIGURE 4], retains a kind of brooding eloquence and is an inventory of exhaustion, from his careworn face to the pinned up empty right sleeve (he'd lost an arm at Waterloo).[28] The white feathers of his headgear fan across his lap like a dead game bird, a trophy of mortality. Raglan was in fact unwell and would be dead of dysentery within the month. The formality of this portrait is typical of the way Fenton treated the highest ranking officers.

As he descended the ranks both his depictions and the postures of the

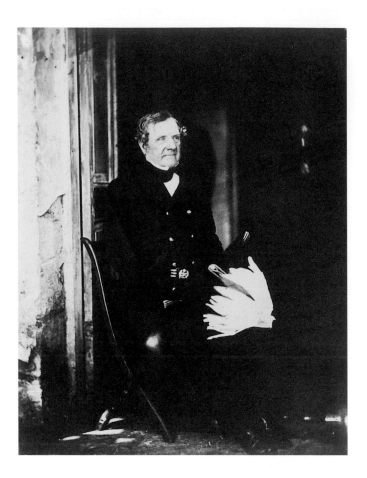

Figure 4
Roger Fenton.
*Field Marshall Lord
Raglan*, June 4, 1855.
Salt print, 19.8 ×
15.3 cm (7 13/16 × 6 in.).
Los Angeles, J. Paul
Getty Museum.

men became increasingly relaxed, although they were never unposed. There is thus a visual hierarchy that reflects the structure of the army.[29] His studies of vulnerable ordinary soldiers, jaunty for the camera and perhaps each other, yet camped in hostile terrain for which they were inadequately equipped, have a durable poignancy. Fenton brought to the composition of these group portraits a considerable variety of invention [FIGURE 5]. His felicitous photograph of the cooking arrangements of one group of hussars is unusually painterly, largely because the out-of-focus tents and rising terrain behind the men form the equivalent of a theatrical backdrop, making the composition a romantic diorama. That Fenton managed to produce a large body of work in such adverse circumstances

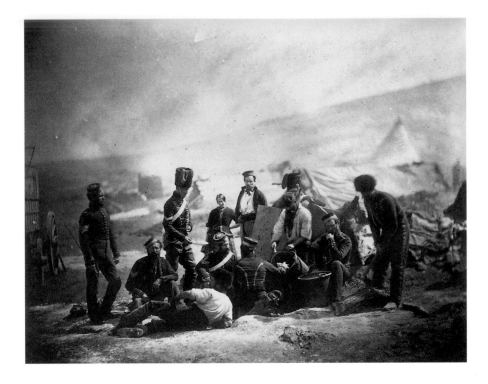

Figure 5
Roger Fenton.
*Cookhouse of the
8th Hussars*, 1855.
Salt print, 15.9 ×
20.3 cm (6¼ × 8 in.).
Los Angeles, J. Paul
Getty Museum.

using a photographic process that would be considered formidably cumbersome today in any situation, is testimony to his remarkable determination.

By late June he was running low on photographic supplies and, although he did not yet realize it, coming down with cholera. After selling his darkroom van, horses, and other gear, Fenton left the Crimea and managed to catch up with the England-bound steamer *Orinoco* in Constantinople.[30] During the voyage home he substantially recovered his health, but from this period forward there was evident an unconventional streak, at least sartorially speaking, as Fenton often wore a kepi and military tunic.

The photographs that Fenton had produced from his Crimean negatives were promptly and widely publicly exhibited in England. By royal and then imperial command, he showed them to Queen Victoria and Prince Albert at Osborne House in early August and to Emperor Napoleon III and Eugénie at Saint-Cloud in mid-September. Both monarchs purchased groups of the Crimean pic-

tures. In the fall Agnew's original intention to publish editions of these images was fulfilled, but even with the added imprimatur of royal sponsorship, the pictures did not sell as well as had been anticipated. Nevertheless they made Fenton famous and remain the work for which he is best known. They also effectively opened a new chapter in the uses of photography.

In all probability when Fenton went to see the Emperor of the French in 1855 he also visited, perhaps with other members of his family, the Paris Exposition in which he was exhibiting a number of landscapes as part of a group shown by the Photographic Society and for which he had won a first class medal.[31] He would have also wanted to examine the photographs exhibited by his other compatriots and by such French colleagues as Le Gray, Le Secq, and Nègre,[32] with whom, as Secretary of the Photographic Society, he had consistent contacts. It was also an opportunity to see work by other European photographers and from farther afield, from America and Australia, although it would have required a considerable amount of time to cover all of this ground in what was a very large exposition, crowded with both people and exhibits. He would not have missed the views of Constantinople by James Robertson, the Scots photographer who was the chief engraver of the imperial Turkish mint, as those works were hung nearly next to the work of the Photographic Society. Robertson had also made photographs in the Crimea, beginning about the time that Fenton departed, and like Fenton he won a first-class medal at this exposition. In its vastness the exposition provided lavish painting exhibitions as well, some of which, particularly the significant retrospectives of Delacroix and Ingres, included Orientalist themes.

In the following two years, 1856 and 1857, Fenton regularly showed new work by placing it in at least twelve different exhibitions in London, Edinburgh, Paris, Brussels, and lesser cities, but most notably at the Manchester Art Treasures Exhibition of 1857. He was also instrumental in arranging the participation of members of the Photographic Society in several of these shows. He continued to work for the British Museum and the royal family and became involved in what turned out to be a financially unsuccessful publishing venture, the Photogalvanograph Company, which issued a series of photo-engravings, mostly from Fenton's negatives, but also from those of William Lake Price and others.

He was now at the height of his powers as a landscape photographer,

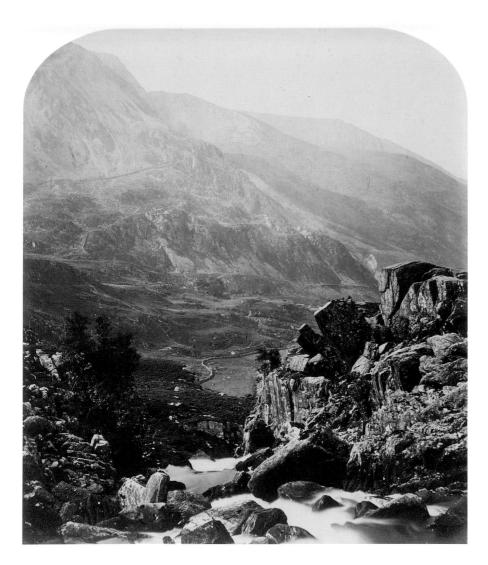

Figure 6
Roger Fenton.
*View along Benglog Falls
into Nant Ffrancon*, 1857.
Albumen print, 42.2 ×
36.5 cm (16¹¹/₁₆ ×
14³/₈ in.). Los Angeles,
J. Paul Getty Museum.

and landscape comprised the bulk of his new work. It necessitated carefully plot-
ted, slow-moving travel up and down England and into northern Wales and south-
ern Scotland, in another, newer carriage converted into a closed darkroom and
heavily laden with glass plates and chemicals.[33] His view down past the Benglog
cataracts into the valley of Nant Ffrancon seizes the rugged, boulder-strewn land-
scape and the glacial scrapings along the bare flanks of the mountains of the

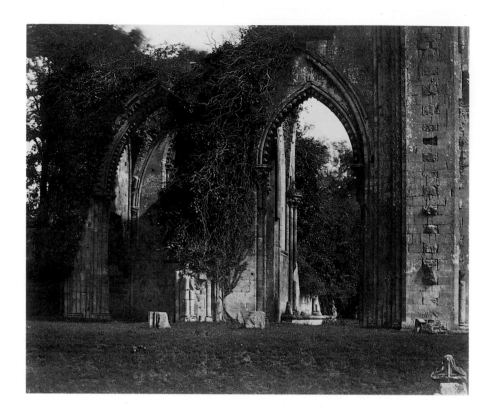

northwestern corner of Wales [FIGURE 6]. His vertiginous camera placement causes the foreground rocks to fan out like a poker hand against the great void below. One can only wonder at the precipitous descent ahead for his lumbering carriage, presumably fully braked by Sparling, crawling down from the top of the pass. The only element that softens this bleak sweep of view is the water tumbling at the viewer's feet, transformed into the burbling fumes of dry ice by the long exposure of the negative in the camera. It is a measure of the breadth of Fenton's vision and his responsiveness to a variety of topographies that his landscapes range from this craggy view to idyllically still scenes along river bottoms. During this period Fenton also extended his series of pictures of cathedrals to include Ely, Lincoln, Peterborough, and York. His view of the ivy-drenched ruins at Glastonbury is reminiscent of Wordsworthian poetry [FIGURE 7]. The growth of the vines is so densely lush as make them appear of an antiquity equal to that of the venerable

stones. Fenton has made the band of foreground grass into a horizontal block, a plinth for the emphatic verticality of the transept arch that rises at the right. The darks fall to the left, counterweight to the massive masonry. The fragment of stone that pins down the lower-right corner serves as a sort of carver's signature or a collector's chop. Fenton's ability to fix architecture to the page while clarifying its geometries and imbuing it with majesty was much admired.

Inevitably he made pictures closer to home as well, including views in the London parks. In 1858, while he continued his work in landscape and architecture by moving on to new regions, he also undertook a further expansion of his range of subjects. That summer he produced his series of Orientalist images, the tableaux of persons posed to resemble domestic scenes of Middle Eastern life that are the specific subject of this book. He continued to make his work public, particularly in the annual January exhibitions of the Photographic Society, of which he was now a nearly permanent vice president. In addition to his large-format pictures he had begun to produce stereoscopic views. He seems never to have produced cartes-de-visite, despite their growing popularity at the end of the decade, but even considering his work for Queen Victoria, portraiture had never been his strongest suit. In 1860 and 1861, he went on making photographs of cathedrals, ruins, colleges, and country houses, and for the first time, still lifes of fruits and flowers [FIGURE 8]. These ripe, densely packed compositions resemble both Dutch seventeenth-century still-life painting and work by his contemporary George Lance.[34] Their effectiveness is the result of careful arrangement, varieties of refracted light, and the tactile play of differing textures, of smooth and sharp skinned fruits, textiles, fringe, glass, silver, and basketry. They represent a conscious effort on Fenton's part to extend the range of photography into another traditional category of painting.

About this time he became involved in the volunteer militia movement, documented some of its rifle competitions with his camera, and was made a (perhaps honorary) captain. In October 1862 at the age of forty-three he startled his fellow members of the Photographic Society by announcing his entirely unexpected retirement from photography. At the end of the year he sold his negatives and all of his photographic equipment and returned to the practice of law in what seems to have been a somewhat desultory manner, uncharacteristic of his normal

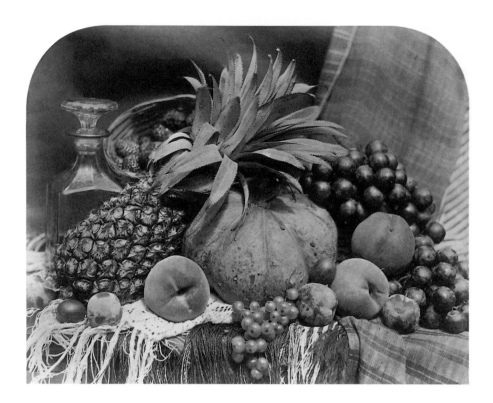

brisk style. As would have been normal for a fledgling lawyer, which in effect he was, having occupied himself with other pursuits for so long, he apparently followed a circuit of the assizes judges and may also have become some sort of advisor to the Stock Exchange. Law, no doubt, seemed a safe harbor by comparison with the turbulent waters of photography, now roiled by the craze for the carte-de-visite. It should be noted that apparently Fenton's health had not been strong since his return from the Crimea, and that his life had not been without a heavy measure of sadness. Two of his five daughters and his only son had died, even in the Victorian period a high toll for a family of his class. In addition the largest of the Fenton family mills had been closed down the year before because of an intrafamily dispute about whether it should continue using water power or should be modernized by converting it to steam.[35] This closure, which proved to be permanent, may very well have meant a loss of income to Fenton and prompted him to look elsewhere for money. When he had taken up photography in 1852, lacking prototypes

for emulation, he could not have had much idea about where it would take him, either artistically or financially, and for some time he regarded it as more hobby than profession.[36] It was only toward the end of the 1850s that photography in England passed out of the hands of gentlemen and amateurs and opened up as a profession to be pursued. Its new and lower social status, coupled with its perceived inferiority to painting and the traditional arts, may not have accorded with Fenton's idea of his own station. Nor had two of his larger-scale photographic enterprises proved as remunerative as he might have desired—the Crimean pictures had not sold as well as anticipated and the Photogalvanograph Company had run up a considerable debt.

This is not to say that Fenton was poor in 1862. At about this time he began construction of a substantial but unpretentious house on several acres of land that he had bought in 1859 at Potter's Bar in the country north of London, recently made accessible to the city by railroad.[37] It was from that house and his chambers in London that he practiced law, particularly in the Northern Circuit where he still had formidable family connections. He died at the age of fifty at Potter's Bar in 1869 after a brief illness, brought on, it was said, by rushing to catch a train. Within a year his wife sold the drawings and paintings in his collection and within less than two, the house and land at Potter's Bar.[38] Much has been made of the size of the Fenton family fortune and its loss in the years after 1861, but may it not be that, as in many family mythologies, the fact of its loss has magnified the size of what there was to lose? Whatever the amounts, the sources of money were not entirely gone until the failure of the Fenton family bank in 1878, but either they were unavailable to Mrs. Fenton or perhaps she only wished to remove herself and her daughters from the house where her husband had died and to divest herself of the sizable number of pictures he had collected.

This then is an abbreviated account of the history of the man who made *Pasha and Bayadère* in the summer of 1858. To determine more specifically the artistic climate that directly contributed to the picture, an examination follows of the Orientalist work in other media that Fenton was likely to have seen in Paris during the 1840s, then of similar work that he must have seen in England in the 1850s, of other Orientalist photographs with which he would have been familiar, and of precedents in his own work.

ÉTUDES: FENTON AND FRENCH ORIENTALISM

Let us assume that Fenton arrived in Paris in the summer of 1842 to study painting, stayed for about a year, returned at the end of 1843 after his marriage, and remained for most of the following four years, 1844 to 1847. By 1848 he had gone back to England. The question is: What did Roger Fenton see in Paris in the 1840s that might have predisposed him toward Oriental themes?

The term Orientalism has been used in a number of ways over time, but roughly speaking in the visual arts it is the depiction of scenes of life in the Ottoman Empire and its dependencies in the Near East and North Africa, that is, a Moslem culture with which only a relatively small but growing number of western Europeans in the nineteenth century had actually had any direct contact. As a result of unfamiliarity and cultural bias, Orientalist images, particularly early in the century, were more imaginative fictions than interpretations of observed life. That projected life was often portrayed as one of romantic splendor, despotism, barbarism, sensuality, indolence, and luxury. Although the expansion of colonial interests, commerce, and steam travel brought about increased contact, Orientalism was characterized by the persistent refusal of the Western mind to reduce the lure of the East to anything like the humdrum data of daily existence. As a phenomenon in the pictorial arts the craze for Oriental imagery, however falsified, embroidered or enhanced, reached its apogee in the second half of the century.[39]

Even before Napoleon's military adventures in Egypt in 1798 and 1799, Orientalism in French art already had a considerable history, but after them interest in the Near East gathered momentum.[40] Several of the paintings of Baron Gros (1771–1835) commemorated the Egyptian campaign, but they are perhaps better described as glorifying French military exploits rather than evoking visions of the Orient. Another result of that extended foray, the encyclopedic publication by Vivant Denon of the *Description de l'Egypte*, issued in twenty-four volumes between 1809 and 1829, continued to feed French appetites for Near Eastern subject matter. This large work may have been unknown to Fenton, but in the sale of

Fenton's collection of prints and engravings in 1870 there was a bound volume of plates from Denon's earlier *Voyage dans l'Egypte* of 1802.[41] This included views of towns, temples, ethnic and costume studies as well as the places where Napoleon's military engagements occurred. Perhaps Fenton purchased this book as a student in Paris with a larger than ordinary income (and a wife with one and then two children). Its costume studies would have given him some specific ideas about the look of the Near East before he ventured there. They would constitute a somewhat subliminal base from which the Orientalist photographs would come.

No student of painting in the last decade of the July Monarchy could have been unaware of the work of Eugène Delacroix (1798–1863), who was extremely active in the 1840s fulfilling major commissions from the government of Louis Philippe and consistently exhibiting at the annual salons.[42] Among painters of that period, only Gericault and Ingres were as famous. Evidence of a direct connection of Delacroix with Fenton is nonexistent, although coincidentally Delacroix

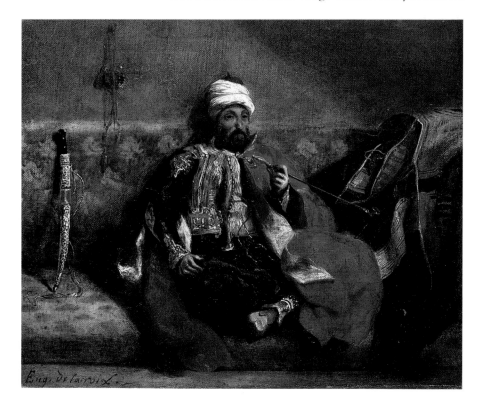

Figure 9
Ferdinand Victor
Eugène Delacroix
(French, 1798–1863).
*Turk Sitting on a Sopha
Smoking*, probably 1825.
Oil on canvas, 24.7 ×
30.1 cm (9¾ × 11⅞
in.). Paris, Musée du
Louvre, © R.M.N.

would be elected to the Académie in 1857 to replace Delaroche, Fenton's putative instructor in painting. Delacroix was interested in photography, however, and in the 1850s he became associated with Jean-Louis-Marie-Eugène Durieu (1800–1874), who would make photographs at Delacroix's direction as preliminary studies for drawings and paintings.

Orientalism is one of the most important aspects of Delacroix's artistic vision, and its pervasive influence can be found as early as such paintings of the 1820s as *Turk Seated on a Sopha Smoking* [FIGURE 9].[43] This small painting, done before Delacroix had even set foot in North Africa, is a clear indication of his pre-existing interest in this genre, which had already found grander expression in his better-known romantic work, *Scenes from the Chios Massacres* (Musée du Louvre, Paris). The latter painting, which was on exhibit in the Musée du Luxembourg during Fenton's time in Paris, was drawn from horrifying contemporary events in the Near East that took place during the Greek revolt against the Ottoman Turks. The more modest image of the smoking Turk is of wholly different character and is as much a study of the sitter's clothes as of his face and posture. Similarly Fenton's photographic study of a man smoking at ease on a divan is also about Islamic costume [FIGURE 10].[44] As this is probably the picture that Fenton titled *Turk and Arab* when he exhibited it in 1859, an explicit comparison is being made between the two men. The reality of Fenton's picture is somewhat suspect in that although the two men seem social equals, one sits while the other stands. Delacroix's sedated sitter, who uses a chibouk for his tobacco, is straightforwardly depicted. Fenton's employs a nargileh, although a seemingly carelessly dropped chibouk extends diagonally across the carpet. Beyond the clothing, in both pictures other exotic textiles are included, both for their visual interest and to further establish differences between the world of the sitters and that of the viewer. Both pictures depict a life that is seen as habitually languorous, a characterization fundamental to orthodox Orientalism, whether in painting or literature. Fenton could not have been specifically influenced by this picture by Delacroix, however, as it was in private hands from before 1843 until 1906.[45]

Delacroix was one of the first of the nineteenth-century artists actually to visit the Islamic world, and after traveling to Morocco in 1832 as part of a government expedition his involvement with Orientalist imagery became even

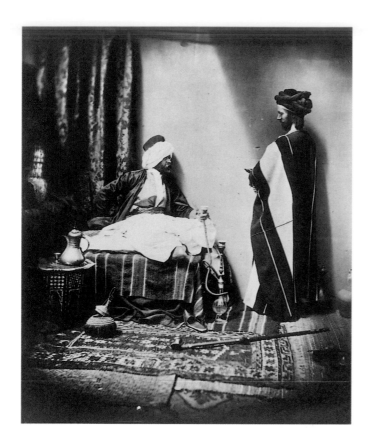

Figure 10
Roger Fenton.
*A Conversation While
Smoking (Turk and
Arab?)*, 1858. Albumen
print, 31.9 × 26.6 cm
(12⁹⁄₁₆ × 10½ in.).
Topanga, Michael Wilson
Collection.

stronger. Despite the difficulties of sketching in a Moslem country where artists
working in the street were likely to be stoned by street urchins, presumably
because of the Moslem prohibition against representational images but perhaps
because of general xenophobia, Delacroix produced a large body of work. The
drawings and watercolors that he made on the spot were followed by etchings and
paintings on his return to France [FIGURE 11]. Morocco provided Delacroix with
lifelong subject material, and the work it inspired can be said to have set the stan-
dard for French nineteenth-century Orientalism.

Delacroix's *Arabes d'Oran* originated as a drawing in a sketchbook that
was transformed into a watercolor while he was still in Morocco in 1832. In France
the following year the subject, with the composition reversed, became an etching.
It then metamorphosed in 1834 into an extremely similar oil painting that

Delacroix exhibited at the Salon of 1835, and two years later he reworked the image, once again in watercolor.[46] The etching was for sale in Paris during the time that Fenton spent there. As a collector Fenton would surely have browsed the establishments of book and print dealers where he could have seen it, along with Delacroix's many other lithographs and aquatints with similar subjects. He could also, of course, have visited Delacroix's studio. The reclining posture of the man on the left brings this image close to Orientalist works by Fenton.

Not only did his trip to Morocco reinforce Delacroix's pre-existing interest in the Near East, it had a transformative effect on his sense of light and color, leading him to produce what have been called the most memorable realizations of Oriental themes in French art.[47] A somewhat lesser example among these works is a painting shown by Delacroix in the annual salon of 1841, a year before Fenton's stay began, the *Jewish Wedding in Morocco* (Musée du Louvre, Paris) [FIG-URE 12]. It was acquired by the duc d'Orleans and given to the Musée du Luxembourg where it was hanging by 1844.[48] Thus this picture would have been readily available to Fenton during a large part of his time in Paris; as a man vitally interested in the arts it is almost certain that he would have visited the Luxembourg. The central area of the painting where light cascades from above onto the figure of a dancing girl and three musicians, although laterally reversed, is similar to Fenton's *Pasha and Bayadère*. Where Delacroix has concentrated attention on the dancer and musicians by framing them with foreground figures whose backs are turned to the viewer, Fenton has simply moved in closer to his subjects. In Delacroix's painting the musician with the tambourine stares avidly at the dancer, but her performance is not specifically directed toward a single person. In the Fenton photograph the dancer effectively has an audience of one, the "pasha," whose appreciativeness rivals that of the tambourine player here. The difference is between a private performance and the public celebration of a wedding. Moreover, we know that Delacroix's painting was executed from notes and sketches he made while attending a wedding in North Africa.[49] In Fenton's case, however, we have no evidence of his ever actually witnessing a dance, nor for that matter, ever entering a private dwelling in the Near East. He spent very little time in Constantinople, and the Crimea was a war zone.

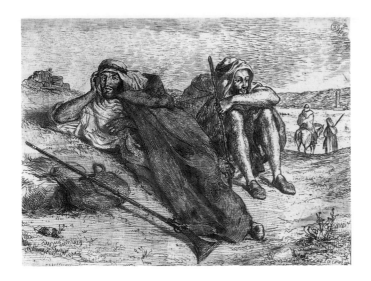

Figure 11
Eugène Delacroix.
Arabes d'Oran, 1833.
Etching, drypoint and
roulette, 14.5 × 18.9
cm (5¹¹⁄₁₆ × 7⁷⁄₁₆ in.).
Los Angeles, private
collection.

Figure 12
Eugène Delacroix.
*Jewish Wedding in
Morocco*, 1837–1841(?).
Oil on canvas, 105 ×
140.5 cm (41⁵⁄₁₆ ×
55⁵⁄₁₆ in.). Paris, Musée
du Louvre, © R.M.N.

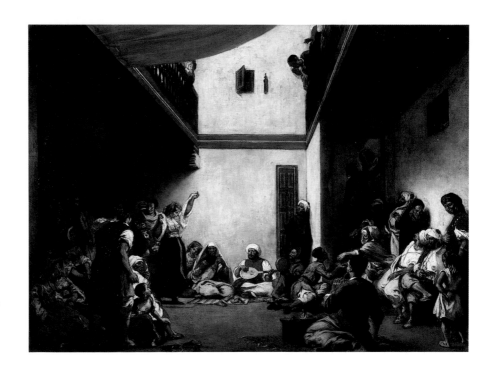

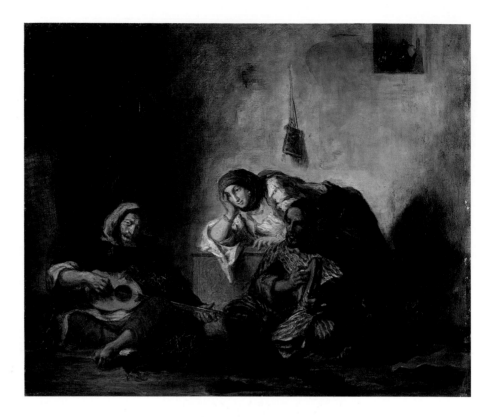

Delacroix exhibited work with North African origins at the Paris salons of 1844, 1845, and 1847, but it was not until that last year that its subject matter again closely resembled what would be Fenton's. Along with two other pictures of North African inspiration, Delacroix exhibited *Jewish Musicians from Mogador* (Musée du Louvre, Paris), a painting of two musicians seated cross-legged on the floor playing a lute and a tambourine with a listening woman leaning over a low table [FIGURE 13]. The figures of the men are modified recapitulations of two of the three musicians from the *Jewish Wedding*.[50] Because it is smaller in scale and has only three figures and a simplified setting, it bears a strong generic resemblance to the photographs in Fenton's Orientalist suite without specifically resembling any one of them. It is as if Fenton could easily have made a photograph similar to this painting but omitted to do so—both men had extracted such similar ideas about Near Eastern life. Of Fenton's pictures this painting is nearest to the image in

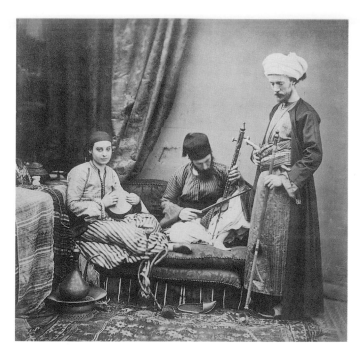

which a woman with a drum sits with a fiddler on a divan, next to which stands an elaborately clothed man, dagger in waistband, chibouk in hand [FIGURE 14]. Delacroix's lute player looks out toward the viewer, mouth slightly ajar as if he were singing. In the Fenton it is the woman whose eyes meet the camera, appraisingly, perhaps resignedly. The figure grouping in the Delacroix is even closer to the ground and as such seems more atmospheric and exotic than the comparatively upright disposition of the figures in the Fenton. The painter's more prolonged and closer study of Near Eastern culture is responsible for the difference. Delacroix's paintings and graphic works comprise the most significant Orientalist images available to Fenton in Paris in the 1840s, and he surely profited by them when he came to make his own pictures of this variety in the following decade. Fenton's own trip to Constantinople and the Crimea in 1855 would have made Delacroix's Orientalist images of particular interest, and his memory of the work would have been refreshed and reinforced by his visit to the Paris Exposition of that year, at which a major retrospective of Delacroix's work was prominently displayed.[51]

The Paris salons of the 1840s included enormous numbers of pictures, as many as eighteen hundred canvases, as well as miniatures, sculpture, and works in the graphic arts. To examine thoroughly all of the exhibited works required extraordinary stamina and, given the dense hanging arrangements, both good eyes and good weather so that the maximum amount of sun would illuminate the rooms from the skylights above. As the salon, which usually opened in March, was the most notable artistic event of any year, Fenton would have gone to all those that occurred while he lived in Paris. Delacroix was only one of the painters to exhibit Orientalist works in the salons of this period, but most of the other artists who produced work in this genre have become obscure. Among the lesser lights were Biard, Caminade, Chaine, Dauzats, Fouquet, Garneray, Genain, Gibert, Lottier, Philippoteaux, Schlesinger, and Vinit, who, with many others, exhibited paintings with titles that indicate that their subjects were drawn from the Near East.[52] Not surprisingly, most of those that were derived from real life had Algerian origins, as that country was already under French dominion. Very few were drawn from either Egypt or Turkey. The proportion of paintings with Orientalist subjects in the salons did not vary considerably nor was the number high, never reaching much beyond forty of the eighteen hundred, mere islands among the vast sea of others.

Among the painters in Paris in the 1840s, Charles Gleyre has been mentioned as a possible tutor of Fenton because he had taken over leadership of Delaroche's studio on the latter's departure for Rome in 1843.[53] Although Gleyre traveled extensively in the Near East in 1834 and 1835, his work after his return to Paris in 1838 was very rarely Orientalizing but was usually drawn from an idealized vision of the classical world of Greece and Rome. Even if Fenton did study with him, Gleyre's copies of his earlier work were locked away.[54] Fenton could not then have been informed by Gleyre's ethnographic studies of single figures, which in fact bear some resemblances to Fenton's photographs.

Among the better-known French Orientalist painters of the 1840s, two who died early, Prosper Marilhat (1811–1847) and Théodore Chassériau (1819–1856), should be noted here. Marilhat brought back from his travels in Greece, Palestine, and Egypt between 1831 and 1833 ten albums of sketches and drawings, which he then used for the production of romantic landscapes, particularly of Egypt. These scenes, which often incorporated Islamic ruins as well as ancient temples, were

further ornamented with small-scale figures and camels. Six of Marilhat's Orientalist paintings were exhibited in the salon of 1844, so Fenton probably saw at least some work by him. Those pictures would have emphasized the allure of the East to Fenton, but Marilhat's figures are not treated in sufficient detail to have left any durable impression.[55]

An early work of Chassériau, a portrait of the caliph of Constantine on horseback, appeared in the salon of 1845, but its subject is too far distant from Fenton's to be relevant.[56] After a visit to Algeria in 1846, Chassériau was to paint and exhibit a number of other Orientalist works, some of which were closer to Fenton's domestic interiors, but they did not appear until the very end of the 1840s and the beginning of the 1850s, by which time Fenton had returned to England. The work of more famous Orientalists, such as Delaroche's pupil Gérôme, would not be exhibited until well into the 1850s, too late to have influenced Fenton.

When Fenton returned to Paris in the 1850s his principal preoccupation was photography, although he no doubt continued to be interested in painting. His visit to Louis Napoleon and the Exposition of 1855 has already been noted. During that stay he probably would have wanted to visit the photographic establishment of Jacques Antoine Moulin (1802–after 1869), a Paris maker of academic studies for the use of artists.[57] Moulin was also an exhibitor at the Exposition and at this time was distributing Fenton's Crimean photographs. He had purchased the rights to sell, and perhaps to print, Fenton's Crimean photographs from Fenton's publisher, Agnew.[58] This commercial relationship was firmly enough established that on the printed mounts of 1856 for the Crimean images Moulin's name is listed, along with Fenton's London distributor, Colnaghi, and a New York distributor, Williams. Fenton's curiosity, and his business sense, would have led him to see the place and manner in which his photographs were being commercially presented to the French public. Since this financial arrangement existed, whatever its precise scope, it is reasonable to think that Fenton may have taken some interest in Moulin's work despite the fact that much of it consisted of academic studies of nudes, some of which verged on the pornographic.[59] For that matter, it is hard to know what Fenton had made of the retrospective of the work of Ingres at the Exposition, which included odalisques. His own ventures in this direction were not so bold.[60]

If Fenton followed Moulin's development as a photographer, the work

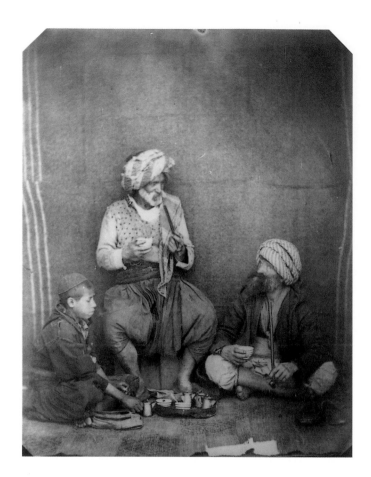

Figure 15
Jacques Antoine Moulin
(1802–ca. 1869).
Algerian Scene,
ca. 1856. Albumen print,
16 × 22 cm (6⁵/₁₆ ×
8¹¹/₁₆ in.). Paris, Bilbio-
thèque Nationale.

that Moulin did in the next two years would have been of great interest. In 1856 Moulin traveled to Algeria, where he remained for some months making views of its cities and studies of its inhabitants. Some of these were published as woodcuts in the press over the next two years, but because of their business connection Fenton may have seen the work privately [FIGURE 15].[61] Moulin's staged views of domestic interiors are necessarily wholly different in character from those of Fenton because the models are more or less what they seem to be and because the photographs were made in real places—in Oran, Algiers, or Constantine—rather than in a London studio. They lack the effects of lighting that Fenton was able to manipulate, but they have the slightly messy feel of reality. Like Delacroix, Moulin

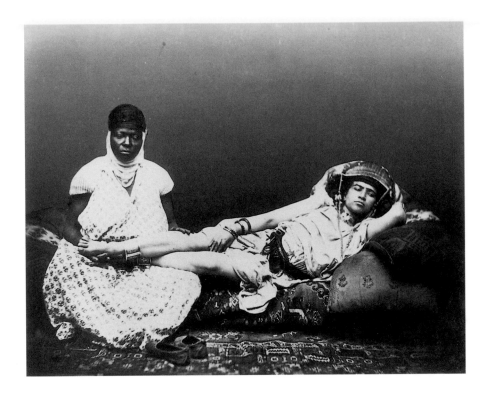

Figure 16
Jacques Antoine Moulin.
*A Moorish Woman with
Her Maid*, ca. 1856.
Albumen print, 18.2 ×
22.8 cm (7⅛ × 8³¹/₃₂
in.). Los Angeles, J. Paul
Getty Museum.

often used Algerian Jewish women as models because of their willingness to pose without veils. As these pictures were not exhibited until 1859, Fenton would have to have seen them privately to have been influenced by them in the production of his Levantine scenes.

Moulin's photograph of a Moorish woman and her maid was one of a number of such studies included in an album purporting to celebrate the visit of Napoleon III to Algeria in 1865 [FIGURE 16].[62] The negative was actually made during Moulin's 1856 trip, so Fenton could have seen it before he made a somewhat similar picture as part of the Orientalist suite [FIGURE 17]. In Moulin's picture the model's bare feet are cradled in the lap of her maid, who holds them with one hand. The maid's other hand is protectively placed at her mistress's knee. These gestures display an evident intimacy between the two women and imbue the photograph with an implied narrative. The principal subject's legs and arms are provocatively naked and her right hand trails across her thigh, giving the image

33

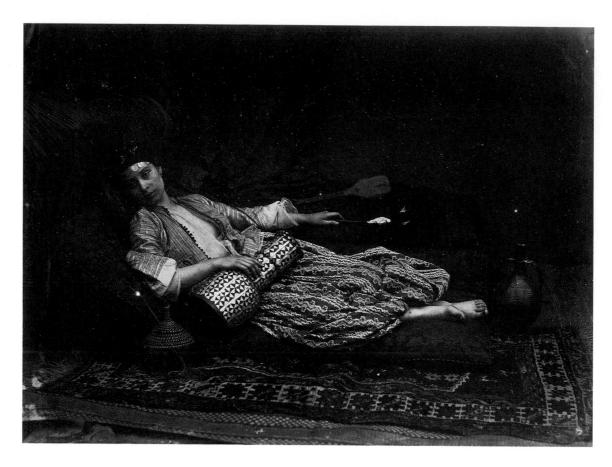

Figure 17
Roger Fenton.
Reclining Odalisque,
1858. Albumen print,
28.5 × 39.0 cm (11³/₁₆
× 15³/₈ in.). San Fran-
cisco, William Rubel
Collection. (Courtesy of
Hans Kraus, Jr.)

considerable erotic content despite her haughty glare in the general direction of
the camera. The bracelets and ankle cuffs with which she is adorned seem to be
additional tokens of amorousness. The guardian maid's eyes are impassively down-
cast, her body is far more covered, and she seems to radiate disapproval of the pho-
tographic process while her mistress is nearly defiant, confronting the camera with
her physicality.[63]

Although Fenton's model is also barefooted, she is languorously
stretched out alone on her divan, one arm draped lazily over a table drum, the
other along the couch. The drum, a *darabukke*, that rests across her lap is hardly a
barrier, but the significant sexual content here rests elsewhere, in the filmy blouse
that partly bares one breast and in the dreamy vulnerability of her face, turned

appealingly toward the viewer, who has interrupted her reverie. It is as if she is adrift in an erotic haze. Did Fenton recall the thirteenth stanza of Tennyson's "Recollections of the Arabian Nights"?

> Then stole I up, and trancedly
> Gazed on the Persian girl alone,
> Serene with argent-lidded eyes
> Amorous and lashes like to rays
> Of darkness, and a brow of pearl
> Tressed with redolent ebony,
> In many a dark delicious curl,
> Flowing beneath her rose-hued zone;
> > The sweetest lady of the time,
> > Well worthy of the golden prime
> > > Of good Haroun Alraschid.[64]

Fenton's reclining odalisque is one of the very best of his Orientalist pictures, transcending the limits of the genre to produce a touching and vulnerable portrait of the woman.[65]

His and Moulin's photographs share not only the supine postures of the women, but also stylized settings filled with highly patterned cushions and rugs. From their unrestricting clothing and languorous poses everything about the women in both photographs boasts of an apparent freedom from societal constraints, of acquiescence and sexuality. Given Moulin's earlier, more erotically explicit work, there can be do doubt that the sexual overtones are intentional and that whatever the woman's status in her own society, he is exploiting her. As a paid artist's model, Fenton's odalisque would have had minimal social respectability, but it is significant that Fenton did not apparently press her further into undress than an uncovered breast.[66] Nor did he choose to exhibit this image. He was less willing to venture as far into explicit eroticism as Moulin did and was unwilling to publicly associate his name with what he did produce. Moulin set an outer limit to which Fenton did not wish to travel.[67]

TRAVELERS' NOTES AND POET'S LICENSE:
BRITISH PICTORIAL ORIENTALISM

Orientalism was gaining currency in England in the years immediately leading up to 1858, and Fenton had opportunities at home to catch the growing interest in exotic subject matter. Among the forerunners in this field were the widely publicized Middle Eastern pictures of David Roberts (1796–1864). Roberts can conveniently be thought of as a topographic artist and delineator of architecture whose figures generally are the animate and subordinate parts of a luminescent scenery composed of monumental buildings. Because of the centrality of the figures in Fenton's tableaux, Roberts's work would not have been fully relevant to his undertaking. Roberts's tiny, picturesquely grouped figures are not fully realized individuals in their own right, although they sometimes serve a minor didactic purpose, pointing up the difference he imagined between the indolence of the present-day Arab and the energy required to erect the monuments of the past, an attitude Fenton may have shared.[68] Nevertheless, while Fenton was aware of Roberts's pictures, they would not have been immediately before his mind, as they had nearly all been executed, exhibited, and published in the previous decade.[69]

As a few of the drawings made in Albania and the Middle East by Edward Lear (1812–1888) at the end of the 1840s are costume studies, they might have been of more immediate interest to Fenton than the work of Roberts, but as they were not exhibited at this time it is unlikely that Fenton saw them. Little trace of a connection between Lear and Fenton seems to exist.[70]

By the middle 1850s pictures in watercolors or oils with Orientalist themes were appearing in larger numbers in London exhibitions, although they would become considerably more popular in the following three decades. By convention, whenever figures were prominently present in these Orientalist images, they seem to have been considered an artistic subset of genre painting and akin to costume studies. When the figures were of secondary importance, they were thought of as views, as part of the topographic class. Views from an ever-increasing number of foreign locales were becoming common as artists traveled farther and farther

afield in search of new subject material and also, as Julie Lawson has pointed out, new colors and perhaps new styles.[71] A not unusual hypothetical progression for an adventurous, and usually unmarried, artist was to begin in one year by making drawings on the Rhine, to move on the next to Italy and Spain the following, each winter returning to London to exhibit the spoils of his conquests. (No women seem to have pursued this course.) This itinerancy is not unlike Fenton in his photographic van criss-crossing the British Isles each summer to produce views of new places for exhibition the following winter.

To some extent the reappearance of Levantine pictures in increased numbers, particularly in watercolor, was simply part of a geographic expansion of the field of visual reference that was facilitated by improved means of transport and accommodations for travelers. In some instances artists remained abroad for longer periods, but ultimately the aim of all was to display their trophies on what might be deemed the London altar of imperial cultural expansion.[72]

The venues for exhibition for these artists were principally five. Foremost was the May exhibition of the Royal Academy, which was staged at this period in the National Gallery. A prestigious juried exhibition open to a very wide range of contestant artists, it was also an important social event and an opportunity for the rising upper middle class to acquire contemporary work in lieu of the ancestral portraits that they had not inherited. Secondary exhibitions included those of the Royal Society of British Artists, held in rented rooms in Suffolk Street, also juried but apparently open to all comers; the exhibitions of the British Institution; and those of the "Old" and the "New" Water Colour Societies. The Old Water Colour Society had more prestige than the New because of its greater age and because its exhibitors were drawn from its limited roster of members.[73] The exhibitions of the Old Society were then held in its chambers in Pall Mall East, usually in late April to coincide with the annual May show of the Royal Academy. Most of the exhibitions of these organizations benefited from the interest, if not the outright patronage, of Prince Albert.

In the 1856 exhibition of the Royal Academy, the landscape painter Thomas Seddon (1821–1856) showed three Orientalist pictures: *An Arab Sheikh and Tents in the Egyptian Desert*; *Dromedary and Arabs at the City of the Dead, Cairo*; and *Interior of a Deewan, formerly belonging to the Copt Patriarch, near the Esbikeeyah,*

Cairo.[74] Fenton, as a former painter—he had exhibited at the Royal Academy himself as recently as 1851—and as a frequent buyer of pictures, although more often watercolors than oils, would surely have attended the Royal Academy exhibitions. There was an enthusiastic response to Seddon's pictures on the part of the public, the press, and potential purchasers, moreover Fenton would have been sure to notice them because the two men knew each other and may be assumed to have been friends. Both had been instrumental in 1850 in the founding of the North London School of Drawing and Modelling (in Camden Town) for the instruction of workmen. Token of their friendship was the pencil drawing by Seddon that Fenton owned and that survived as part of his estate, to be sold in 1870.[75] The pictures Seddon exhibited in 1856 had been painted during his 1854 residence in Cairo. He had traveled there to be joined by the energetic Pre-Raphaelite painter William Holman Hunt, who had agreed to take Seddon, then more a draftsman than painter, under his artistic wing. Seddon's success with these pictures led him to return to Egypt at the end of 1856 in order to fulfill commissions he had received for further work with similar themes. Shortly after his return to Cairo he died of dysentery. A large memorial exhibition of his work was held at the Society of Arts the next year, which would have given Fenton further opportunity to see the work.

Seddon's three paintings of Egyptian subjects were not the only ones of that ilk in the Royal Academy exhibition of 1856. Frank Dillon (1823–1909), a constant traveler and painter of scenes distant from England, who like Seddon had also spent time in Egypt two years earlier, exhibited two paintings with similar titles to Seddon's, *A Sakiyeh on the banks of the Nile, near Philae*, and *Evening on the Nile*.[76] One can assume that Fenton also saw these pictures, although Dillon can only be tangentially linked to Fenton. Dillon was apparently acquainted with Fenton's friend Carl Haag (see below), as a photograph of an Arab girl seated in Dillon's studio existed in Haag's collection.[77] The next year, 1857, there were fewer Orientalist pictures at the Royal Academy, but Dillon showed at least one, *The Tombs of the Sheiks at Assouan*.

Another suggestion to Fenton in 1857 that pictures with Eastern subjects were current legitimate carriers of artistic messages may well have been William Holman Hunt's two illustrations for Alfred Tennyson's "Recollections of the Arabian Nights." As Poet Laureate, Tennyson was already famous, but not yet

a lord. Hunt (1827–1910) was not yet as well known, although he was actively exhibiting in London in the mid 1850s, and Fenton would have already been familiar with his work, since each of them showed paintings at the Royal Academy in both 1849 and 1850. In the exhibition at the Royal Academy of 1856, Hunt contributed four pictures: his well-known *The Scapegoat*, painted along the shores of the Dead Sea; a landscape from the same region; a view of Jerusalem; and another of the great sphinx and pyramids.

Proof that Fenton was already well acquainted with Tennyson's work was his use of the opening line of Tennyson's ballad of 1832, "The May Queen," as the title for the painting that he exhibited at the Royal Academy in 1849, *You must wake and call me early*. Fenton's painting, now lost like all his others, must have been a genre piece depicting the excited girl of the ballad who anticipates her crowning on the following day.

When Edward Moxon (1801–1858), Tennyson's perennial publisher, brought out a substantial and elaborate collection of the poet's work in 1857, known thereafter as the Moxon Tennyson, he included "The May Queen." He also included the earlier "Recollections of the Arabian Nights," which had first appeared in 1830. For this deluxe edition Moxon commissioned several Royal Academicians, including Daniel Maclise (1806–1870) and Augustus Egg (1816–1863),[78] as well as the Pre-Raphaelites John Millais (1829–1896), Dante Gabriel Rossetti (1828–1882), and Hunt, to provide illustrative drawings, which were then transformed into engravings for printing. Of the six designs Hunt provided for the book, the two that bracketed Tennyson's fantasy of the Arabian Nights had distinctly Eastern subjects. Hunt's drawing that prefaces the poem depicts a languorous youth, hand to brow in recollection, lounging in a fragile pea-pod shaped craft, fitted with a sail [FIGURE 18]. He floats, lotus blossoms at arm's reach in the water, against a background of palms, domes, and minarets. True to Hunt's established procedure of always working from exhaustive documentation, however, the backdrop was not an invention but an adaptation of a sketch Hunt had made in 1855 of the actual skyline of Constantinople, which city, he said, had "delighted my soul by its excessive beauty and picturesqueness."[79] His reaction to that city differed radically from Fenton's initial utter disdain for it. Unlike Fenton, Hunt re-created his Near East from carefully recorded observations in situ, even if the location of

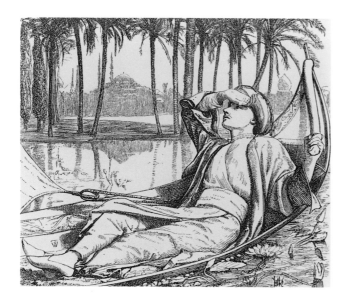

Figure 18
William Holman Hunt
(British, 1827–1910).
*Recollections of Arabian
Nights*, 1856. Engraving
by J. Thompson (British
school, active 1850s)
from the pen and sepia
and wash drawing by
Hunt, as published in
Alfred Tennyson's
Poems, pg. 102; 8 ×
9.4 cm (3⅛ × 3¾ in.).
Santa Monica, The Getty
Center for the History of
Art and the Humanities.

Figure 19
Roger Fenton.
*Prince Alfred as 'Autumn'
in the Tableaux of the
Seasons*, February 10,
1854. Salt print with
applied color by Carl
Haag; 17 × 20.6 cm
(6¹¹⁄₁₆ × 8⅛ in.). Wind-
sor, The Royal Archive,
© Her Majesty Queen
Elizabeth II.

Tennyson's poem was an imagined Baghdad rather than Constantinople.

The drawing that Hunt provided to close the poem was less detailed. It is a sketch of an elderly man, perhaps a scribe, seated in an alcove of nearly inde-terminate architecture and affixing a seal to a document, perhaps Hunt's idea of the imaginary writer of Tennyson's poem. As Hunt's sketch was less than finished, the engraver, Thompson, was given scope to supply many details, particularly a sword at the sitter's side, which effectively makes the figure a pasha not a writer. The general effect is to remove the subject into a world of mixed referents. Thompson had, to an extent, Orientalized Hunt's actual Orientalia and brought it closer to Fenton's (and for that matter, Tennyson's) imprecise Eastern world. Both of Hunt's drawings lost some of their authenticity, that is, their particularity of observed detail, in the translation into engravings.

In short, the issuance of Moxon's Tennyson in 1857 gave Fenton a clear literary and visual model of the use of Orientalist imagery in contemporary British works of art. The book was issued in an edition of ten thousand, and although it did not sell nearly as well as Moxon had hoped, it must have been famil-iar to Fenton.

Carl Haag (1820–1915), another of Fenton's acquaintances, also set out

to capture Orientalist images in 1858. Haag, a Bavarian-born watercolorist, had emigrated to England in 1848, where through his connections with aristocratic Germans his artistic skills had attracted the attention of Queen Victoria. He had worked for the queen primarily in 1852 and 1853 at both Balmoral and Windsor, painting pictures of stag-hunting and of her family. In 1854 he had been employed to add color to some of Fenton's photographs of the royal children acting in the tableaux that the family regularly staged to celebrate birthdays and anniversaries [FIGURE 19]. The effect of Haag's applied color is to make Fenton's photograph of a somewhat annoyed Prince Alfred, steadying himself by leaning against a draped pedestal, closely resemble one of Haag's normal run of costume studies.[80] On Victoria's birthday in May 1854 she was given a crimson portfolio containing photographs by Fenton that had been colored by Haag.[81]

Fenton's connection to Haag was closer than their mutual employment by Queen Victoria and is consistently traceable, if no longer documentable on an intimate level. Each acquired work by the other. Fenton owned two works by Haag, a study of a Neapolitan orange vendor and another of an Italian shepherd, both probably painted in 1856 when Haag had traveled to Italy. These remained in Fenton's collection until his death and were sold at auction in 1870.[82] Similarly, Haag acquired four of Fenton's Orientalist studies of 1858, probably directly from the artist rather than from an exhibition, as they are not among those that Fenton exhibited in January of the following year, by which time Haag was out of England in pursuit of further Orientalist subjects.[83]

Haag exhibited at the Old Water Colour Society, of which he was a member, in 1857 and 1858. Fenton bought work by at least twelve other of its members and was also connected to it through his activities as secretary of the fledgling Photographic Society.[84] For the latter society's first exhibition in 1854 the Pall Mall rooms of the former were considered as a venue, and its second and third exhibitions were in fact held there in 1855 and 1856. Fenton was involved in all three sets of negotiations for obtaining these premises.[85] Most important, Fenton's Crimean pictures were exhibited in the chambers of the Society in October 1855. In short, Fenton's association with this organization and its members was lasting and significant.

When Haag left England in late 1858 in search of picturesque subject matter, he traveled with a fellow member-to-be of the Water Colour Society,

Frederick Goodall (1822–1904).[86] They spent the next year and a half in Egypt and elsewhere in the Middle East. It is interesting to speculate that Haag and Goodall may have been stimulated to travel to the East by either Fenton's newly made pictures or by conversations with him about his Crimean expedition, although Haag was already a consistent voyager. When they returned to England a year or so later both continued to paint Egyptian genre scenes derived from their travels, and on this kind of work their later, very long artistic careers rested, evidence of the continuing force of the Orientalist tradition in British art. Certain exotically decorated corners of the large studio that Haag later built in Hampstead in the Egyptian style resembled the setting that Fenton had assembled to use in the production of the Orientalist suite.[87] Goodall went even farther by importing Egyptian sheep to fill his garden and thence his canvases.

Goodall's connection to Fenton remains slightly conjectural, but it should be noted that Fenton had met Goodall's older brother Edward Angelo Goodall (1819–1908) in the Crimea in 1855, where he was making sketches for the

Figure 21
Roger Fenton.
The Water Carrier, 1858.
Albumen print, 26.1 ×
20.6 cm (10¼ ×
8¹/₁₆ in.). Bath, The Royal
Photographic Society.

Illustrated London News.[88] Fenton also owned two watercolors by Goodall's younger brother Walter (1830–1889).[89] Whether they knew each other or not, it seems quite possible that a figure in Frederick Goodall's 1863 painting *The Song of the Nubian Slave* [FIGURE 20] is directly dependent on one of the best known of the Fenton photographs from the Orientalist series, *The Water Carrier* [FIGURE 21].[90] The pose of the woman balancing a water jug on her head in the foreground of the painting is exactly that of the woman in the photograph, save that in the painting it is her left arm that is raised to steady the jug rather than her right as in the photograph. The posture is in part dictated by the act being performed, which in the case of carrying a water jug on one's head is not perhaps susceptible of great variation, but the images of the two women are remarkably alike even unto the suspect weightlessness of the identical jugs. Like the wrists of the dancing woman in *Pasha and Bayadère,* the jug in *The Water Carrier* is supported by wires, which in this case have been so skillfully retouched that they are barely visible. Fenton may have intended that his Orientalist images be used by other artists as if the photographs were

preparatory drawings, but it is likely that he also hoped they would stand on their own as works of art. His resurrection of an aspect of his Crimean experiences to produce Orientalist pictures is akin to watercolorists and oil painters working from their sketches. In the Crimea, when he found himself without his camera and portable darkroom, Fenton sometimes made drawings, so he too may have had sketches from which to work.[91] If such studies once existed, they are now lost.

Another connection linking Fenton to the Old Water Colour Society was his friendship with his fellow photographer William Lake Price (1810–1896), who before taking up the camera had been an artist.[92] His subsequent photographic career lasted only about ten years, but then so also did Fenton's, and there are other parallels in their lives. Both originally trained as artists and both were exhibiting members of the Photographic Society in London. Both had work included in the *Photographic Album of 1855*, one of the first important compendiums of photography, and both exhibited at the Manchester Art Treasures exhibition of 1857, where Lake Price uniquely showed photographs as well as watercolors.[93] Both made photographic portraits of the royal family, both were included in the second portfolio of prints by the Photogalvanograph Company in January of 1857, and both joined the Volunteer movement in 1859. Price was best known for his photographic recreations of literary scenes drawn from Shakespeare, Cervantes, and Defoe. These he staged with careful attention to props, costume and lighting. His study of a suitably demented Don Quixote [FIGURE 22] was the most famous image of his career, in part because of its reproduction by the Photogalvanographic Company, of which, as noted, Fenton was a principal. The rampant disorder of the Don's study characterizes his madness more thoroughly than facial expression could ever do, although its disarray is, of course, more artful than accidental. The preparations for photographing this kind of scene are closely related to those that Fenton undertook for his studies of Eastern life. Like Fenton, Price was an important proponent of the idea that photography should be made to serve the ends of art. His overtly literary choice to portray Cervantes's hero bespeaks his aim.

Lake Price and Carl Haag are the only two persons we can name who actually acquired Fenton's Orientalist images. Price placed the three that he possessed in an album that, although primarily devoted to his own productions, also

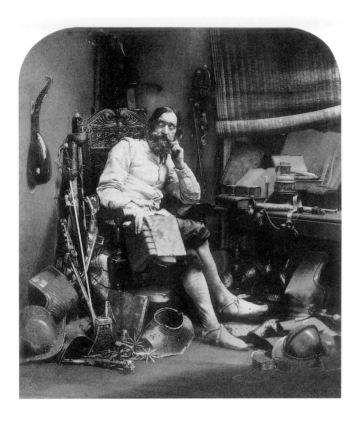

Figure 22
William Lake Price
(British, 1810–1896).
*Don Quixote in His
Study*, 1857. Photogal-
vanograph, 22.7 × 19.6
cm (8 15/16 × 7 3/4 in.);
Los Angeles, J. Paul
Getty Museum.

contains work by his contemporaries.[94] It is significant that these images appealed to Fenton's artistic coevals, both of whom were themselves involved in the creation of pictures that did not primarily reflect contemporary British life.

Because of his substantial connections with the Old Water Colour Society, Fenton can be presumed to have attended their annual exhibitions.[95] From 1850 forward there had been at least some pictures exhibited with Orientalist themes, most notably the work of John Frederick Lewis (1805–1876), who in late 1855 became the president of the Society for a brief period. Fenton would have come into direct contact with him during the negotiations for the rental of the Pall Mall premises for the third exhibition of the Photographic Society.

The first British painter to live abroad for an extended period of time, Lewis can be considered to be the most prominent and accomplished of the British Orientalists of the mid-nineteenth century. His life has some resemblances to that

of Dillon, but his work is of a higher order. Lewis was elected an Associate of the Old Water Colour Society as early as 1827, where he exhibited conventional views of Scottish, Italian, and Spanish subjects until 1841. After a hiatus of ten years, during which time he was living in Egypt, he again started exhibiting in 1851, startling the audience with a view of the interior of a harem. Both its exotic subject material and its fanatically meticulous execution were unlike other work then being exhibited. It was the prototype for a picture he would paint several more times in the years that followed, and he thought highly enough of it to exhibit it again in the Paris Exposition of 1855, where Fenton may have again seen it. In 1852 Lewis exhibited a picture titled *An Arab Scribe*, a wood engraving of which was published in the *Art Journal* in 1858, so Fenton could have seen it in reproduction even if he hadn't attended the annual watercolor exhibition [FIGURE 23].[96] The *Arab Scribe* was also exhibited at the Paris exhibition in 1855, so Fenton had three opportunities to see some version of this image. In short, Lewis exhibited so consistently in London in the mid-fifties that Fenton could hardly have been unaware of his work. Lewis was at least an acquaintance of Frederick Goodall and Carl Haag as all three were members of the Clipstone Street Artists Society, a sort of artists' collective that hired street people, gypsies, and singers to pose in the evenings.[97] Studio sessions were followed by dinner.

Lewis's work was often highly praised by John Ruskin, who thought him second to Turner in the pantheon of British painters. Ruskin particularly admired Lewis for his "conscientiousness of completion."[98] In 1857, for example, Lewis exhibited at the Old Water Colour Society a large picture titled *Hhareem Life—Constantinople*, [FIGURE 24] which won him somewhat less praise from Ruskin than the picture he had exhibited the year before, but praise nevertheless, although Ruskin felt that Lewis had gone nearly too far in his obsession with detail and finish, and worried about the survival of all this intensive work, given the frailty of watercolor as a medium. As Ruskin's own drawings were highly precise, for him to criticize Lewis for too much concern with minutiae indicates just how fastidious Lewis was in the execution of his work. The way that light passing through a latticework screen is made to shiver into a multitude of tesserae in a Lewis watercolor could not, however, be more different than the broader effects and greater contrasts of light in a Fenton photograph. It is as if Lewis's subject has

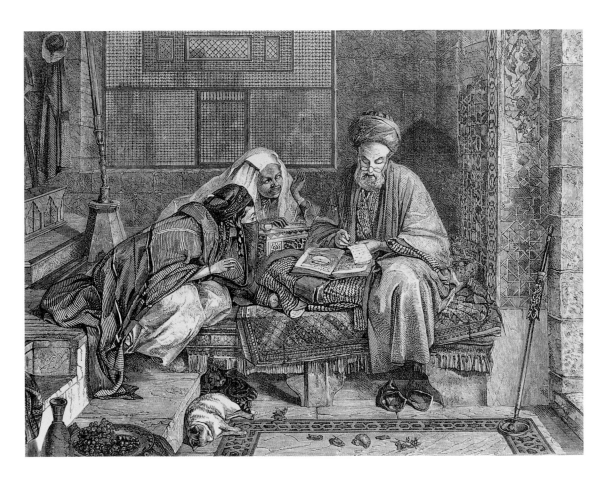

Figure 23
John Frederick Lewis
(British, 1805–1876).
The Arab Scribe, 1852.
Engraving by Mason
Jackson (British, 1819–
1903) from the water-
color by Lewis, as pub-
lished in *Art Journal*,
1858, pg. 43; 13.6 ×
18.2 cm (5⅜ × 7⅛ in.).
Santa Monica, The Getty
Center for the History of
Art and the Humanities.

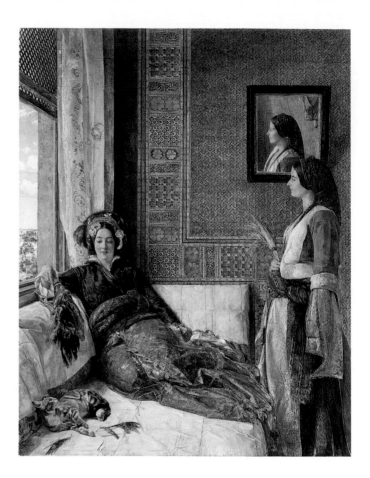

Figure 24
John Frederick Lewis. *Hhareem Life—Constantinople*, 1857. Watercolor and bodycolor, 62.3 × 47.7 cm (24½ × 18¾ in.). Newcastle-upon-Tyne, Laing Art Gallery (Tyne and Wear Museums).

been softened and veiled by the act of depiction, while in Fenton's photograph the camera has visually demystified the subject by the crispness it conveys.

 A reviewer for the *Art Journal* praised Lewis for his "laborious accuracy" and inestimable patience and noted that the reclining figure displayed "the profound listlessness of oriental life."[99] This detailed work was typical of his lifelong production in watercolor and oils. Lewis soon resigned from the Society and afterwards exhibited mainly at the Royal Academy, where in 1858 he exhibited five Orientalist subjects. Fenton made his photographs of this kind in the summer of 1858, so Lewis's works could well have been an immediate impetus for their creation. One of the five pictures by Lewis was an interior view of a harem, called variously *Life in the Harem, Cairo*, and *Inmate of the Harem*, which is now in the collection of

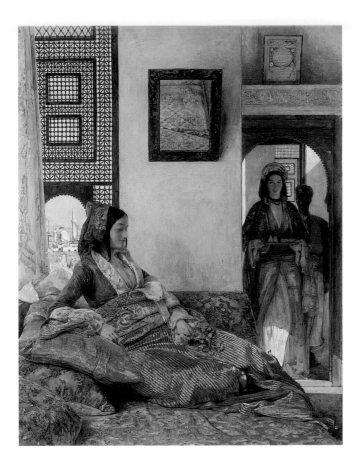

Figure 25
John Frederick Lewis.
Life in the Harem, Cairo,
1858. Watercolor and
bodycolor, 60.7 × 47.7
cm (23⅞ × 18¾ in.).
London, Victoria & Albert
Museum.

the Victoria and Albert Museum [FIGURE 25]. In addition to Lewis's work, there were at least six other pictures in the May exhibition that year that had Orientalist themes.[100] Clearly, however, Lewis's pictures must have stood out because of their number and the favorable notices they received, even if Ruskin's enthusiasm had begun to wane and if W. P. Frith's *Derby Day* was the sensation of the year.

Fenton had another opportunity to see pictures by Lewis at that vast compendium of British art, the Manchester Art Treasures exhibition, which had opened in May of 1857. Besides work by Lewis there were other pictures with Orientalist themes. Whether or not it was possible for one person to actually see all that was on view—there were nearly one thousand watercolors alone—the opportunity was present. Among the six hundred and one photographs were seven land-

scapes and one architectural study that Fenton himself had sent to the exhibition. Lewis was generously represented by ten watercolors, of which two were Orientalist. Similar works were two by the short-lived but stylistically influential Richard Parkes Bonington (1801–1828): an oil, *A Turk Enjoying a Siesta*, and a watercolor, *A Felucca*, which was owned by Frank Dillon.[101] Dillon also loaned a watercolor by William John Müller (1812–1845) entitled *Arab Sheick* [sic]. Müller, whose style had been influenced by Bonington, was another of the peripatetic painters who traveled widely in search of material. Like Bonington he had died young. He was represented by three oils of Egyptian subjects and a number of watercolors from places like Greece and Syria. There may not have been many Orientalist works at Manchester, but there were enough to make it clear to a careful observer like Fenton that it was a viable strain in British art. The Exhibition also had a highly decorated Oriental Court filled with carpets, ivories, statues, embroideries, furniture, pictures, and porcelain—a glorious jumble of art from China, India, Persia, and the Near East.

Lewis had lived for nearly nine years in Cairo and his later work is based on the multitude of sketches that he made there and elsewhere in the Middle East. He had thoroughly steeped himself in his subject material by living outside the European quarter of Cairo, adopting local dress, and generally conforming to Egyptian customs. He sketched constantly, in the streets, mosques, and souks of the city, gradually accumulating a very large collection of drawings, not only of scenes but also of the components of Moslem architecture, actual lattices, shutters, mosaics, and tilework patterns. He also made portraits of the inhabitants, from street vendors to members of the government, including Ibrahim Pasha, the nominal ruler of Egypt. Lewis's nearly maniacal devotion to rendering detail, as for example in the delicate latticework of the window and the even more complicated tilework on the wall in *Hhareem Life*, gives his pictures the presumption of authority. As Linda Nochlin has stated about genre work in general and the Orientalist art of Gérôme in particular, "such details, supposedly there to denote the real directly, are actually there simply to signify its presence in the work as a whole."[102] Lewis's devotion to detail was not an isolated phenomenon. Hunt, who was well aware of Lewis's example, made numerous studies that he then incorporated into later works, but he seems to have collected fewer morsels than Lewis. According

to Kenneth Bendiner, Hunt's intention in pursuing this data in a quasi-scientific manner, roughly analogous to ethnological methodology, was an attempt to recapture the visual actuality of the biblical world through the contemporary Arab world.[103] In an effort closer to that of Fenton's, Lewis was concerned with gathering in the present.

The standard that Lewis had set for rendering interior decorative detail would be emulated in diminished degree by later painters. By comparison, the photographs of Fenton seem almost Spartan, despite his efforts to assemble a set of authoritative props; they are simply sketches of an imaginary life rather than fully worked-up pictures. Nevertheless, they were compared to the work of Lewis, a veritable touchstone for the evaluation of Orientalist work. It was, of course, considerably easier for Lewis to add authenticating detail to his work by means of pencil and brush than it would have been for Fenton, who was constrained to purchase, borrow, or relocate actual objects. Still, it is more profitable to compare Fenton's work to Lewis's than to that of his other contemporaries, in part because the relentless presentation of detail throughout Lewis's paintings is similar to the specificity that the camera was able to record. Also, in many of Lewis's indoor pictures the relation of figure to ground is somewhat similar to that found in a Fenton photograph. Each was at least nominally interested in the portrayal of a specific event, and they were more interested in Moslem private life than were Goodall, Dillon, or Roberts before them. In addition, because both Fenton and Lewis were concerned with the depiction of private life—that life which in Moslem culture was most removed from the experience of Europeans and usually actually forbidden to them—both Fenton and Lewis had thereby greater imaginative freedom. On the surface, neither's work was grounded in Western social situations.[104] The exterior parameters of the pictures of Lewis and Fenton, and to an extent the psychological incidents, or what Henry James would have called the "given" of their situations, was similar.

Despite the comparative simplicity of Fenton's pictures as to the number of objects employed to establish a *mise en scène* and the lack of elaborated background, contemporary reviewers seem to have felt that a truthful account of Eastern life had been presented in his photographs.[105] This kind of judgment resulted in part from the fact that for contemporary viewers any familiarity with

Near Eastern cultures had come from exposure to the same kinds of Orientalist oils and watercolors that Fenton himself had seen in the previous few years and perhaps from other representations of Moslem life in popular culture. Since there were not yet in existence a very large number of photographs depicting daily life that had actually been made by Britons in the Levant, and relatively few people had as yet traveled there except perhaps en route to the Crimean War, in which case their glimpses would likely have been as abbreviated as Fenton's had been, there were no widespread standards for assessing the visual accuracy of these kinds of images. When dealing with the earlier work in watercolor and oil, fidelity to reality had been a standard critical desideratum, and this standard was carried over to photography. It is clear that both the reviewers and the general public were interested in the life that Fenton's photographs or Lewis's paintings purported to represent, although the works of both are ultimately studio re-creations, however much they may have been taken for realities. Fenton was not alone in bringing back to England visions of another part of the world, whether fully realized in paintings and drawings in the case of Hunt, memorandized in sketches in the cases of Dillon, Müller, Goodall, and Lewis, or imagined after the fact as in his own case. He was one of a still relatively small number of messengers.

In the interval between his own return from the Crimea in 1855 and the summer of 1858 when he began his series of posed photographs, Fenton's exposure to Orientalist images by artists whose work we assume he admired must have borne on his decision to work in this vein. More and more of these pictures were being shown toward the end of the decade, and Fenton's timing was not uncalculated. He would exhibit his own work of this character at the very end of 1858, but most important, in the January exhibition of the Photographic Society in 1859.

Eastern Photographs
and Artistic Applications

In addition to the pictorial sources in oil and watercolor for his Orientalist images, Fenton was undoubtedly influenced by the work of other photographers as well. Aside from work by William Lake Price, the most relevant British photographs that Fenton saw in the period immediately preceding his production of Orientalist images were those made by Francis Frith (1822–1898), William Morris Grundy (1806–1859), and to a lesser extent, James Robertson (ca. 1813–1881).

Of these three Frith is by far the best known because of the large number of books containing his photographs that were published after his Near Eastern travels and because of the extraordinarily successful publishing firm that he founded in 1859 in Reigate, which continued in business until 1960. After an unhappy apprenticeship in a cutlery, Frith had become first a wholesale grocer and then a prosperous printer.[106] By 1853 he had become sufficiently interested and versed in photography to become a founding member of the Liverpool Photographic Society. Frith's first photographs of Palestine and Egypt were made in the course of an 1856 expedition specifically devoted to the production of images of biblical sites, a trip that was largely motivated by his personal piety. The immediate success of his large-scale photographs and stereoscopic views, when exhibited and published, caused him to make two additional trips, each of more than eight months, to the Near East in 1858 and 1859 in order to produce additional negatives. Their enthusiastic reception at the April continuation of the annual exhibition of the Photographic Society in London in 1858 was typical. After praising Fenton, who was also an exhibitor, for his usual high standard of selectivity and artistic feeling, the reviewer for the *Art Journal* went on to equate Frith's work with the ultimate function of the medium:

> The real value of photography is, however, most strikingly shown in
> the production of F. Frith, jun. His subjects in Palestine and Egypt
> impress us with a consciousness of truth and power which no other

Art-production could produce. The sands of the desert have for centuries been grinding those gigantic columns and colossal statues; and there, before us, is the abraded stone, every mark being preserved to tell how slowly, but yet how surely, the dust of earth is overcoming the greatest works of man. All those photographs by Mr. F. Frith should be very carefully studied.[107]

The truth-telling factuality of photography was deemed particularly appropriate for the depiction of holy sites. Frith's images, although designed to illustrate the loci of Christianity, more effectively depicted the Islamic and the ancient worlds. As a reviewer for the *Athenaeum* commented about the stereoscopic views: "There is not one of these views of Egypt but that teaches us some new feature of Oriental life"[108] Frith and Fenton would have known each other by this date, as Fenton presided over the 1858 meeting of the Photographic Society during which Frith first described his working experiences in Egypt.[109] Their connection, which was perhaps deeper than we can now document, would continue beyond Fenton's actual photographic career, as at the sale of his negatives in 1862, Frith acquired many of them, including at least a few of Fenton's Orientalist images, two of which Frith then reprinted and adhered to his own mounts but with a credit to Fenton. In the 1860s he also made editions in the form of books of other works by Fenton, most notably photographs of cathedrals.

The majority of Frith's published and exhibited pictures were photographs of monuments or landscapes that intentionally but seemingly incidentally include generic scale figures, not very much more than miniature men amid sand and gargantuan monuments rather than wholly realized studies of persons. There also exist a few genre studies, but they were not in wide circulation at this time. Overall, his pictures had a far less intimate character than the domestic scenes that Fenton was to produce, but in one instance they coincide. In 1859 Frith published *Egypt and Palestine*, his largest collection of plates to that date, containing seventy-six photographs in two volumes. It had first been issued, in parts of three prints each, over a period of twenty-five months, for a total of seventy-five images. Although the overwhelming majority of the pictures were views, whether of Egyptian monuments or Palestinian landscapes, Frith significantly prefaced the book with a seventy-sixth plate, entitled *Portrait: Turkish Summer Costume*, which

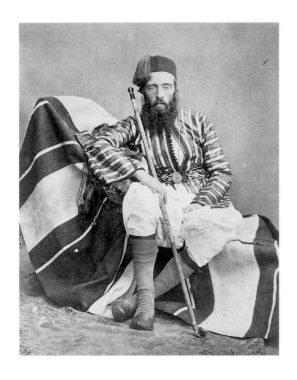

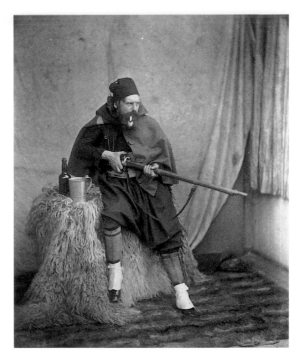

he took care to date 1857 [FIGURE 26]. Although he did not identify the picture as such, it is a self-portrait, and to have placed it as a silent herald for what followed is a way of vouching for his authority to have made the balance of the images, as if to say that clothes do make the man, "I have been to these places and here is proof of my authenticity." His intention was also to present himself in the long tradition of artists' self-portraits in exotic clothing, dating back at least to Rembrandt and including Fenton's rakish depictions of himself in a Zouave uniform [FIGURE 27]. Like Frith, when Fenton printed this picture, as part of his Crimean series in 1855, he did not identify it (or the two variants of it) as a self-portrait but titled it as if it were simply a photograph of an ordinary Zouave.[110]

Like Fenton, Frith made three variants of his picture of himself, varying his pose from sitting upright on a draped couch with a Turkish pipe in hand, to lounging on a pile of Oriental rugs.[111] As a European carpet is visible in one of these pictures, and in another there is what seems to be a European upholstered bench, the pictures were probably made in England after his return in 1857. It is odd

Figure 26
Francis Frith
(British, 1822–1895).
Self-Portrait in Turkish Summer Costume, 1857.
Albumen print, 16.7 ×
12.9 cm (6⁹/₁₆ × 5⅛
in.). Los Angeles, J. Paul
Getty Museum.

Figure 27
Roger Fenton.
Self-Portrait in Zouave Uniform, 1855. Salt
print, 19.2 × 15.9 cm
(7⁹/₁₆ × 6¼ in.).
Topanga, Michael Wilson
Collection.

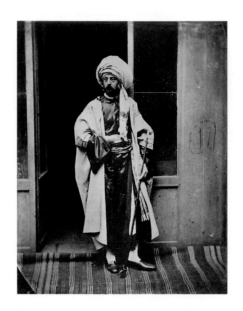

Figure 28
Charles Nègre
(French, 1820–1880).
*Self-Portrait in Orientalist
Costume*, ca. 1860.
Albumen print, 22.9 ×
17.8 cm (9 × 7 in.).
Topanga, Michael Wilson
Collection.

that he took care to describe his clothing as Turkish summer dress in that he never actually ventured to Turkey during any of his three photographic expeditions to the Near East but he may be doing so as part of his general quest for precise description.[112] (It may be that, like Fenton, he did not overmuch trouble to distinguish between the modern populations and costumes of Turkey and Egypt, both parts of the Ottoman Empire.) In the printed caption under the photograph Frith carefully dated the picture as 1857, two years before publication of his book, perhaps in order to establish artistic priority over Fenton's Orientalist pictures.

Fenton and Frith's presentations of themselves in Near Eastern clothing is paralleled by other artists of the period, including Fenton's friend Charles Nègre, whose elegant standing self-portrait of about the same date is perhaps more redolent of a fancy-dress ball than of the exotic East [FIGURE 28].[113] It includes a long tobacco pipe that is nearly a requisite for images of this kind. As Nègre made at least ten other self-portraits between 1850 and 1870, including one in a monk's habit, it is not surprising that in one instance he chose to don Near Eastern clothes despite the fact that he never traveled to the region.

Another example is the self-portrait of the British photographer, William Grundy [FIGURE 29].[114] Although it contains the inevitable smoking

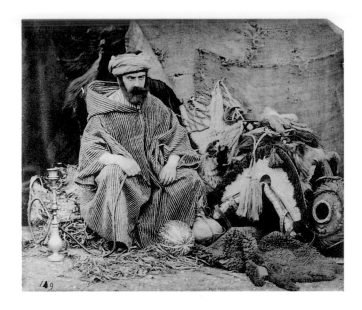

Figure 29
William Morris Grundy
(British, 1806–1859),
*Self-Portrait in Orientalist
Costume*, ca. 1857. Salt
print 18 × 20.3 cm
(7¹/₁₆ × 8³/₈ in.). Bath,
The Royal Photographic
Society.

implement—in this case a nargileh rather than a chibouk—with additional authenticating paraphernalia such as a camel saddle, a jug, and animal skin rugs, Grundy's picture is somewhat unconvincing as a costume study.[115] The combination of phlegmatic British physiognomy, overtly upright posture, and extraneous detail, including a melon and assorted straw mats, is overly complicated and unsettlingly theatrical.

The assumption of fancy dress for the purposes of self-presentation (and glamorization) had a practical function in the field. John Frederick Lewis and Frederick Goodall both wore a semblance of "native" dress while in Egypt, as a kind of protective coloration in Goodall's case, in order to avoid being pestered, as Delacroix had been, by ragamuffins while sketching in the streets, and in Lewis's, as romantic identification with local life.[116] That photographers chose to don such vestments for self-portraits is testimony to the power of Orientalism in art of the period as well as to their abilities to imaginatively project themselves into other situations and identities by appropriation.

Fenton probably saw views of Constantinople by James Robertson at the Paris Exposition of 1855, and if not then, he had opportunities to do so in England in the next few years. As in the works of Frith, Robertson's photographs

included foreground figures, but the present-day inhabitants of the city were of relatively less importance as subjects than the splendid buildings or ancient monuments next to which they sat or stood, although Robertson surely intended to contrast the informality, by British standards, of Turkish posture with the upright magnificence of the monuments.[117] The figures animate the pictures and by their dress and stance serve to remind us that these buildings are not in Western Europe. In his photograph of three people next to the elaborate sculptural reliefs on the base of an obelisk [FIGURE 30] there is an implicit criticism of the present state of dusty Constantinople, in decline from its more glorious past. As Robertson was employed by the Ottoman government, he would not have admitted, at least to a Turk, to an invidious comparison of past and present, but it is hard to believe that the figures are meant only to add local color. His primary intent to document is indicated by another view he made of this four-sided pedestal, which is carefully angled to show the other two sides. To make the reliefs visible he had to be up close, and consequently the figures are more prominent than in most of his pictures.

Robertson also produced small-scale images of street trades in Constantinople that were circulated privately at about this period [FIGURE 31]. His photograph of a barber is one of a series from Constantinople, designed to show both what garments its inhabitants wore and what professions they followed. Others show water carriers, food sellers, dervishes, and shop scenes.[118] In their straightforward presentation and lack of narrative they approach the ethnographic and substantially differ from what Fenton was to do, relying on the unfamiliar garb and trade to make them interesting.

Since the photography theorist and critic Ernest Lacan (1829–1879), editor-in-chief of La Lumière, chided Robertson in his review of the 1855 Exposition for not making his genre pictures available to the public, it's clear that they were being shown around in photographic circles.[119] Lacan's article would have alerted Fenton to the existence of these pictures as he was surely a regular reader of La Lumière, which had both a London correspondent and an office in Skinner Street. In its columns Lacan and others consistently and favorably reviewed work by Fenton, referred to correspondence with him, published translations of his technical papers, and admired proofs of pictures that he had sent. Evidently Lacan and Fenton were also friends as Lacan appears to have visited Fenton's house in Albert

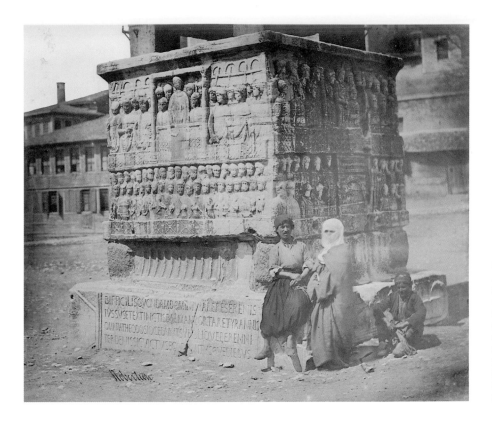

Terrace.[120] Since Lacan was often in London and Fenton sometimes in Paris, there would have been frequent opportunities for them to meet. It is fair to think of Fenton as being the most important link between the photographic communities of the two countries at this time, respected by the French for his artistic achievements and doubly welcomed because of his fluency in their language.

Although Robertson resided in Constantinople, he was not unknown in England. An album of his views of that city had been published by Joseph Cundall in London in 1853, and an album of fifty-three views in Greece was published in London in 1854.[121] That same year thirteen of his pictures were circulated as part of tours organized by the Royal Society of the Arts, with which Fenton was also involved.[122] Three of Robertson's Constantinople views were included in the Manchester Art Treasures Exhibition of 1857, and views were again shown in the exhibition of the Architectural Association in January of 1858, as were pictures of

Figure 31
James Robertson.
Study of a Street Barber.
Albumen print with
applied watercolor, 18.8
× 14.3 cm (7⁷/₁₆ × 5⁵/₈
in.). Topanga, Michael
Wilson Collection.

London by Fenton. Undoubtedly Fenton saw Robertson's city views and he probably saw the costume studies. Either might have stimulated him to think about producing Near Eastern photographs.

Robertson's genre work is now exceedingly rare in part because of technical imperfections that caused many of them to fade to the point where they would not have been worth preserving. Of the few that survive, the majority have applied color, which makes them even resemble the watercolor prototypes from which they derive, bringing them close to the work of such artists as Charles Szathmari (1812–1887).[123] Szathmari was a Rumanian watercolorist and photographer whose work in both media is contemporaneous with that of Fenton and

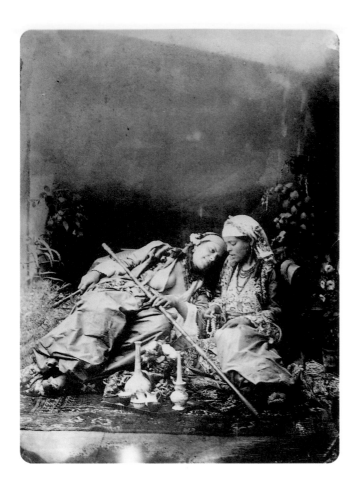

Robertson, although his career extended considerably longer than Fenton's. His
subjects were principally costume studies, whether of Rumanian gypsies, Wal-
lachian peasants, Turkish army officers in Rumania, or Cossacks in the Crimea
(where he had preceded Fenton), or later, "Arab" women [FIGURE 32]. Like Fenton,
Szathmari had exhibited at the Exposition of 1855—an album of pictures from
Wallachia and the Crimea that Lacan liked and linked to Fenton's work. As Szath-
mari's album was part of the Turkish display, it may be unrealistic to think that
Fenton actually saw it among the plethora of other exhibits, but Lacan may have
pointed it out or Fenton may have been independently interested in seeing the rep-
resentation of a country from which he had recently come. Szathmari was more

interested than Fenton in the picturesque per se, and tried to assemble a sort of ethnographic dictionary of costume, while Fenton wished his Orientalist photographs to more closely approach traditional genre painting.

Szathmari's study of two women at ease among cushions and carpets, chibouk and coffee cups, has a more relaxed and voluptuous feel than Fenton's Orientalist images. Part of this can be attributed to the fact that the women are at home in an environment similar to their normal surroundings, even if the furnishings have been moved out into the sunlight to facilitate the process of photography. Perhaps more important, unlike the persons in Fenton's photographs, the women are wearing their normal clothing. That the photographer has encouraged the woman on the left to let her blouse fall alluringly open has measurably increased the sensuality of an already heavily laden picture. The woman on the right is darker hued than the woman on the left and by the code of this genre is probably meant to represent a servant. Whatever the social status of these women, by incorporating into this scene recumbent postures and accoutrements of indulgence, both of which are associated with indolence and sexual license, Szathmari has produced a classically prejudicial Orientalist image, saturated in Western fantasy.

More easily accessible and directly relevant to Fenton's production of Ottoman images were the Turkish studies that William Grundy showed at the Manchester Art Treasures exhibition of 1857 and at the 1858 exhibition of the Photographic Society.[124] They are a direct stimulus for Fenton's decision to make images based on his own experience in the Near East. The life and photographic output of William Grundy are little known. As an exhibiting member of the Photographic Society he and Fenton would have met. His principal body of work, dating from 1857 until his premature death in 1859, was a very large number of stereoscopic views of vernacular scenes and staged tableaux ranging in subject from landscapes populated by cows and rustics, to figures of ghosts appearing to praying persons, to humorous depictions of family life.[125] Earlier he produced somewhat larger-scale views that also showed considerable diversity of subject. Some of the photographs he displayed in 1858 were titled as follows: *At Suez*, *A Turkish Shop*, *At Constantinople*, and *Scenes at Cairo*, of which there were several. Two now untitled photographs by Grundy relate to the work that Fenton was to

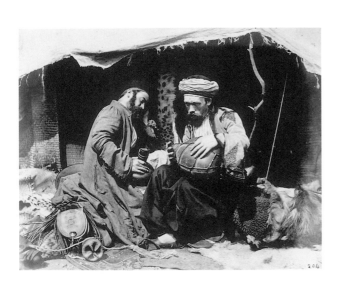

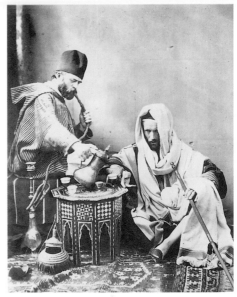

create the same year. The first [FIGURE 32], of a man pouring out drink for another, is posed under what appears to be the edge of a large tent propped up by a branch, but which is more likely simply a canvas stretched out to seem the edge of a tent. The men, apparently social equals, are seated next to one another on what may be camel saddles or low stools surrounded by rugs, mats, and animal skins. The premise for the picture would seem to be the Koranic virtue of sharing water, nourishment, and shelter with guests, which is enjoined on all believers. In four of Fenton's Orientalist pictures beverages are being poured. In only one are the two figures both men and of the same rank [FIGURE 34].[126] Fenton's photograph is different in feel from Grundy's as it depicts indoor urbanity rather than outdoor rusticity, and the beverage is coffee rather than water. Both photographs generally derive from the renown of Arab hospitality, but the Grundy is a specific prototype for the Fenton.

The second photograph of Grundy's that closely resembles one by Fenton is his image of a dozy smoker, propped on a covered stool and lying on a fur rug on top of and against a backdrop of woven mats. He has been posed outdoors but otherwise is strikingly similar to Fenton's indoor picture of a reclining

Figure 33
William Grundy. *Arab Drinkers*, ca. 1858. Salt print, 24.4 × 19.3 cm (9⅝ × 7⅝ in.). Windsor, The Royal Archive, © Her Majesty Queen Elizabeth II.

Figure 34
Roger Fenton. *Afternoon Refreshment*, negative 1858, print by Francis Frith, ca. 1863. Albumen print, 20.9 × 16.6 cm (8¼ × 6½ in.). Topanga, Michael Wilson collection. (When published by Frith this work was entitled *Arab Costume*.)

Figure 35
William Grundy.
Reclining Smoker, ca.
1858. Salt print, 17.1 ×
20.9 cm (6¾ × 8¼ in.).
Rochester, N.Y., Inter-
national Museum of
Photography at George
Eastman House.

Figure 36
Roger Fenton.
Reclining Smoker, 1858.
Albumen print, 18 ×
27.2 cm (7⅛ × 10¹¹⁄₁₆
in.). Topanga, Michael
Wilson Collection.

Figure 37
Unknown French maker,
active 1850s. *Reclining
Smoker*, ca. 1855. Salt
print, 17.9 × 22.5 cm
(7 1/32 × 8 7/8 in.).
Los Angeles, J. Paul
Getty Museum.

man pretending to puff on a pipe [FIGURES 35–36]. The consumption of tobacco is often depicted as part of the supposed luxuriance of male Near Eastern life.[127] Both photographs of smokers are very like another of the same period (traditionally attributed to Robertson, but more likely by a French photographer) of an Algerian man cradling his long pipe against his stretched-out body [FIGURE 37]. That three photographers should produce such similar pictures is testimony to the power of this kind of stereotypical image of a Near Eastern man at leisure. Grundy's pictures of this kind of life were immediately commended by the reviewer for the *Athenaeum* and were explicitly compared to the watercolors of John Frederick Lewis:

> As a true and careful transcription of new scenes, we must give special prise to the useful and engaging *Constantinople Scenes*, by Mr. W. M. Grundy. They beat Lewis—but for colour and honour— and that is saying a good deal—both for their minuteness and their

composition. They are chiefly shop scenes, framed in with striped saddles and arms, sharp-edged brazen pots, cherrywood pipes, slippers, and other Eastern properties. Here is a young Alnaschar asleep, dreaming of the beautiful princess with the antelope eyes; and here is the Calenderer's brother planning, in a quiet brood over his pipe, an excursion to the Magnet Mountain and the Roc's Diamond Valley.[128]

The reviewer employed the same overall criteria for judging the merit of the photographs that he would have used for evaluating watercolors of similar subjects, their apparent directness and their truth to the life represented.[129] While alluding to Lewis's mania for detail, he has overlooked the question of whether Lewis's finished works were accomplished from sketches or memory of his experience in the actual locale and has equated them with Grundy's studio work of an imagined Islam. The writer moves directly from enumerating the authentic actual objects to invoking the reverie of the fictional world of the *Arabian Nights*, placing both on an equal footing for the purposes of forming aesthetic judgments. If this conflation bespeaks an inability or unwillingness to distinguish means from effects, it also indicates the inseparable nature of the dream and the real in much European thinking about the Ottoman world at this period.

The reviewer commended Fenton's Welsh landscapes in the same exhibition for their aerial perspective, finding it "delicious, because true," but this was scant notice as Fenton had exhibited forty pictures, including architectural studies and twelve photographs of works of art. It would not have been much consolation that his work sold for higher prices than Grundy's: ten shillings, sixpence for a Fenton landscape as opposed to seven shillings, sixpence for a Grundy study.[130]

The *Art Journal's* review of this exhibition favorably noticed Fenton and ignored Grundy.[131] The writer for the *Photographic Journal* disparaged Grundy's Turkish images before lavishly praising Fenton's landscapes:

In his studies of fishermen Mr. Grundy is eminently successful, and they will no doubt be highly prized by artists. But in his Turkish studies we are sorry we cannot be so complimentary. If Mr. Grundy had paid attention to national physiognomy, he would have known that there is scarcely any race of men who have such strongly marked features as the Turks. The square conformation of the fore-

head, the sunken eye, the high cheekbones are all marks by which we can so easily distinguish this peculiar race, whilst Mr. Grundy had selected in many instances a thorough Anglo-Saxon physiognomy, dressed with all due care in Turkish costume. This is to be regretted, as it mars the effect of otherwise good pictures.[132]

Bad casting caused the play to fail of its effect. While commending Grundy's careful attention to costume and *mise en scène*, the reviewer of this exhibition in *La Lumière* commented on the same disjuncture, saying that otherwise he could nearly have believed the scene to have been photographed in Constantinople.[133] That paramount quality of the photograph, its "truth," is impugned by erroneous genetics. As is clear in the *Photographic Journal* reviewer's comments about Fenton's landscapes the substantial and the real is what was being sought in photography, and anything that points to artifice was (and perhaps is) disturbing. Whether the reviewer thought that a given photograph would be useful as a study for an artist or should stand on its own to be compared with a painting, all four of the critics explicitly refer to painting for the aesthetic standards by which photographs at this period were to be judged. This same physiognomic discrepancy applied to Fenton's Orientalist pictures and would be pointed out when they were exhibited in 1859.

It is worth noting that by 1858 the complimentary tone of the review of Fenton's landscapes was normal. He was an acknowledged master in this field and for that reason the reviewers sometimes devoted comparatively little space to him, assuming that the public was already familiar with the specific virtues of his pictures, which did not need further description. This somewhat cursory treatment slighted his very hard work in obtaining his landscapes. At this point in Fenton's career it must have been somewhat dispiriting to him to be praised routinely only for his command of aerial perspective when his aspirations for his own work and for photography were so much higher.

Grundy's work in this exhibition and at Manchester, and the attention paid to it, must have suggested to Fenton that by drawing on his own experiences in the Middle East he might profitably take up the same subject material with better results. His specific aim in doing so was the production of images of higher quality than Grundy had achieved, not so much technically as artistically. Happily, we have Fenton's thoughts on Grundy's work and from them we can actually mark

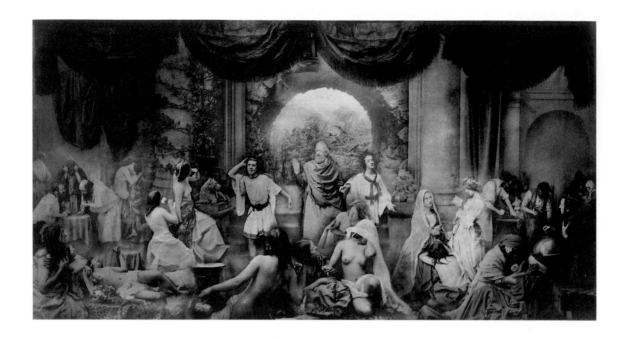

Figure 38
Oscar Gustav Rejlander
(British, born Sweden,
1814–1875). *The Two
Ways of Life*, negative
1857, print 1925. Car-
bon print, 40.9 × 76.8
cm (16⅛ × 30³⁄₁₆ in.).
Bath, The Royal Photo-
graphic Society.

the genesis of his own Orientalist pictures: at a meeting of the Photographic
Society in April 1858 during the run of the exhibition discussed above, Fenton
temporarily resigned the chair in order to join a discussion on the subject of pho-
tography and art.

The evening had begun with the presentation of a paper by the painter
turned photographer O. G. Rejlander about how he had made his large-scale pic-
ture *Two Ways of Life*, a complicated (and overwrought) allegoric composition
from many negatives that had recently been shown at the Manchester Art Trea-
sures Exhibition to the accompaniment of great controversy [FIGURE 38]. To pro-
duce a composition that included a welter of figures, each of which had a specific
if somewhat simplistic symbolic value, Rejlander had taken it upon himself to
arrange separately each of his many models in an appropriate pose and with an apt
expression for the role being played. Each pose had also to harmonize with those
of the adjacent figures and its place in the overall composition. Having made a
series of thirty negatives of discrete areas of the composition, he then sequentially
and painstakingly printed the component parts so that each matched the others in

tone, lighting, and proportion. He had hoped, he said, that one of the results of his six weeks of work would show a painter how photography might be used in lieu of traditional preliminary sketches. He concluded by saying that "Art is the study of life, and photography is like a brush full of paint—use it as you are able."[134]

The ensuing discussion swiftly moved from the purity of Rejlander's intentions in making the picture to the relation of photography and art. Fenton then entered the conversation by saying that at a recent meeting of the copyright committee of the Society of Arts, of which he was a member, he had defended the position that photography deserved copyright protection as art. He felt that the works in the current exhibition, although imperfect, showed the beginning of the "artistic application of photography." He deemed Rejlander's picture overly ambitious and turned to the work of Grundy:

> I will refer particularly to a picture by Mr. Grundy, of Birmingham, of the Wilkie or Teniers kind. It is a picture of a Fisherman—a single figure, in which the lines have all been artistically arranged, the *pose* of the figure, and the *chiaroscuro*, have all been studied—there is everything in it but colour, and even that is suggested—there is expression also, though doubtless of a low order. The question was started, whether it was possible to obtain a picture of a high character from the actual living model? To that picture I would refer as an answer to the question, as an answer to it with respect to a lower description of art. If you wish to answer it with respect to a higher art, you have only to take the same pains, in the conception of the subject, and in the selection of suitable models, to meet with the same success as you have done with a lower class of subjects. I make these remarks in the hope that they will draw out your approval or dissent, that they will attract the attention of the Society to what has been done already and stimulate its endeavours to carry out that little to a greater degree of perfection.[135]

This passage gives a glimpse not only of Fenton's energetic participation in the affairs of the Photographic Society but also of his high and earnest hopes for the art of photography. He felt that Grundy's photograph was somewhat successful, but as a picture of "low" character, that lowness a result of its particu-

lar theme and its model's expression. To understand the thrust of his remarks about the production of high and low art, terms Fenton borrowed directly from the theory of painting, one should bear in mind that during the mid-nineteenth century, the art of painting was still classed according to subject, with history painting—that is, pictures of scenes from religious history, classical mythology, great literature, or actual historical events—at the top of the rank. In descending order followed portraiture, landscape, genre painting, and still life.[136] The origins of this theory can probably be said to be Aristotelian. Its rudiments found codification in the French academies of Louis XIV, particularly in the work of Boileau and Félibien, and it was fully endemic to the British academic system as well, as reflected in the *Discourses* of Sir Joshua Reynolds.[137]

These precepts would have been absorbed by Fenton during his study of painting in Paris in the 1840s, and he remained faithful to them throughout his photographic career. Underlying his remarks, and perhaps also the hierarchical principle as an ordering precept, there is a veiled class-consciousness, reflected in the words "of a low order [of expression]," "suitable," and "lower class of subjects." Although all these can be taken to be reference to the place of genre pictures in the artistic hierarchy, they also denote an inherent belief in the highly structured social order that comprised Victorian England and in which Fenton may have felt his place was less than secure.[138]

One of Fenton's principal motivations in beginning to make Orientalist images himself a few months after this meeting of the Photographic Society was, it seems, to produce images that outshone Grundy's rather static pictures. By injecting a more clearly defined and vivid anecdotal thread he would bring his photographs more into conformity with storytelling painting of the period, including his own canvases of the late 1840s and early 1850s. This thread, its dramatic theme, is what he referred to as the essential underlying conception that determined the work's place in the continuum from high to low art. His comparison of Grundy's images to those of Wilkie and Teniers makes it clear that he considered Grundy's photographs to be genre pictures, and he, no doubt, would have similarly placed his own Orientalist work. Although he wanted to improve upon Grundy's pictures, he was not aiming at "high art." When he chose his models, however, he must have hoped that they were capable of expressing a higher range of feeling than Grundy's,

that they were, as he put it, "suitable" for depicting his ideas.

Fenton's visual erudition and collecting predilections are evident in his offhand reference to Teniers and Wilkie to typify Grundy's work. Fenton's large collection of graphic work included engravings after the work of David Teniers the younger (1638–1685), who unapologetically set his depictions of biblical stories, such as that of the prodigal son, in homely contemporary interiors.[139] Sir David Wilkie (1785–1841), a Scottish painter, was first known for genre scenes and later for royal portraits. Fenton owned engravings after four of Wilkie's better-known genre works, specifically: *The Rent Day*, *Blind Man's Buff*, *Distraining for Rent*, and *The Village Politicians*, which Mrs. Fenton sold in 1870.[140] Curiously, at the very end of his life, Wilkie produced two paintings and a large number of drawings in Constantinople and Jerusalem, portraits and a genre scene. Fenton could have been aware of these late works if he had attended the posthumous Wilkie sale in April 1842 or had seen the London publication of about 1848 of Wilkie's work that included the Oriental sketches.[141] Unfortunately, like Seddon, Wilkie's Eastern trip cost him his life. He died en route home.

The Orientalist pictures were an important step in Fenton's continual quest to make photography a respectable art form. By amalgamating the conventions underlying genre painting with the technique of photography, he hoped to produce work with a strong resemblance to conventional art, worthy of consideration in the same league as painting, even if not its artistic equal. In doing so he came much closer to the work of his contemporaries William Lake Price and Henry Peach Robinson, who had similar aspirations for photography, than at any other time in his career, although his Orientalist images have fewer direct literary allusions than those of Price and are less saccharine than those of Robinson. They are also far simpler than Rejlander's *Two Ways of Life*, although that picture was perhaps useful in setting the outer limit for staging scenes. He set out, then, in the summer of 1858 to produce his own scenes from Turkish life.

TABLEAUX AND EXOTIC SOLDIERY:
FENTON'S EARLIER PHOTOGRAPHS

Figure 39
Roger Fenton.
*The Royal Children in
A Tableau Vivant*, Febru-
ary 10, 1854. Salt print,
17.1 × 16.6 cm (6¹¹⁄₁₆ ×
6½ in.). Bath, The Royal
Photographic Society.

There were, of course, photographic antecedents in Fenton's own work that relate to both the making and the content of his Orientalist photographs. The Victorian passion for dressing up, which must have been, in part, a form of escapism from a restrictive environment, found expression in one of their principal parlor amusements, the staging of tableaux vivants. In the early 1850s Fenton had photographed Queen Victoria's children in their costumes for a tableau [FIGURE 39]. Although the awkwardness of these photographs reflects Fenton's lack of experience with portraiture at this early period, it should be said in mitigation that he was working in an improvised studio in the palace that was probably not amenable to rearrangement. He was further restrained by the youth of the participants and the formal nature of the tableau itself. In addition, the costumes seem somewhat ungraceful and the children uncomfortable or perhaps just impatient, made to hold long poses in what one might have assumed to be drafty rooms except for the bare legs of a dozing princess. Unlike adults at play in parlor presentations, the children's sense of liberation from everyday Victorian life must have been minimal, constrained as they were to pose for the camera. These pictures are more designed to record

costumes and commemorate an occasion than to tell a story, and as such do not fall into the category of genre photographs.

Closer to his Orientalist photographs in carrying narrative content was a series of four pictures Fenton made in the same year, 1854, to tell a simple story in modern dress of a successful courtship [FIGURES 40–41]. Their interpretation is analogous to reading a genre painting of the period, in which each gesture is meant to reinforce a narrative whose principal theme may be revealed to the modern viewer only by the picture's title, so unused have we become to expecting that there be a story or to reading the symbolism of gesture, deportment, clothing, costume, setting, or property. In these two pictures from the sequence of four, the progression of the tale can be discerned. In *Popping the Question*,[142] the couple is alone and unchaperoned, the young woman's eyes are modestly directed downward, and although she permits her hand and one shoulder to be lightly held in presumable anticipation of what lies ahead, she still sits squarely, formally, on the rustic bench, as does he. Evidently from the title and pose of the fourth and final picture, *The Honeymoon*, his proposal was accepted, and they have married. They make eye contact, she smiles, he grins, and their bodies are relaxed and interlaced, bespeaking the intimacy of a honeymoon. No one else is present—this degree of physical familiarity would have been considered unseemly in polite

Victorian society. We can tell that Fenton intended this short series as no more than a lighthearted look at courtship and marriage, rather than as a serious tale with moralizing content, by the fact that throughout the series the couple wear the same clothes and are posed on the same bench draped with the same shawl in a garden that does not grow, thus violating considerations of time and place. These pictures now seem more a photographic pastime, the work of a pleasant afternoon, than an attempt at anything more.

The most important precursors in Fenton's own work of his Orientalist images are the large group of photographs that he made in the Near East in 1855. Without his experiences in Malta and Constantinople en route to the Black Sea and in the Crimea itself he might never have come to make the pictures that comprise the Orientalist suite. The letters he wrote on his outbound trip convey his initial impressions of the Near East and imply his attitude to its culture. They form his only known written statements about Moslem territories and their inhabitants. Interestingly, he had traveled at least part of this route at some earlier time, as he jokes to his wife in his letter of February 27, 1855, that he thought Gibraltar "not half so brisk as the last time I saw him" and that no doubt if the rock could reciprocate in speech he would say the same of him.[143] This earlier sea voyage is unrecorded; it could have been to Italy or perhaps to Egypt, which at this period was beginning to attract sizable numbers of visitors, although a trickle by comparison with the flood to come.[144] Whatever the destination of his first trip, he had not been to Malta, from which he wrote his impressions on March 2. "We walked all about Valetta. The brilliant sunshine, flowers in full bloom, and the novel architecture and varied costumes seemed like a frieze taken from the Arabian Nights."[145] This tells us, among other things, that he was acquainted with the famous collection of Arab tales, of which a new edition translated by the early Islamic scholar and longtime Cairo resident Edward William Lane (1801–1876) had been issued in parts with commentaries between 1838 and 1840.[146] The *Arabian Nights* would have influenced Fenton's view of the Near East, as would Lane's annotations about Arab culture if, as is likely, it is this translation that Fenton read.

From Malta his steamer proceeded to Constantinople. His first impression of the city from the water by moonlight was highly favorable, but on entering

the town the next day, March 3, 1855, as he wrote to his publisher, William Agnew, his delight turned to dismay:

> Of all the villainous holes that I have ever been in, this is, I think, the worst. What with French and English, Turks, Greeks, Armenians, Italians and nondescript, it seems like a new edition of the Tower of Babel.[147]

During his four-day stay in what he described as a chaotic and crowded city, pulsating with pedestrians jammed into narrow alleys, he and an army officer went on horseback to shop in the bazaar:

> . . . a place roofed in—all alleys and passages with shops on each side, the owner sitting cross-legged smoking on one corner of his bench. The Turks may be a grave people, but they made plenty of noise and fun in trying to sell their wares. [After bargaining for red forage caps] I got a pair of velvet slippers and some attar of roses, the genuineness of which I have my doubts. There were several women shopping in the bazaar. The way they cover their faces, letting only their eyes be seen, is very coquettish, the more so as if their's is a good face the veil is of so transparent a material that the beauties it covers can be easily divined.[148]

This letter is the only one in which Fenton writes about purchasing anything Turkish, but his failure to name any of the clothing or the properties that furnish his Orientalist photographs is not conclusive evidence that some of them were not acquired on this trip. He may, after all, have wanted to surprise his wife with gifts from Constantinople or not thought it worth enumerating everything that he had bought.

After his shopping expedition, the tourist's obligatory visit to Hagia Sophia followed, and in the vast and airy basilica he observed the following:

> There was an old Turkish fellow sitting cross-legged on one side, surrounded by a circle of other men, all squatting, to whom he was

expounding the Koran. As far as I could judge from what his tone and manner indicated, he seemed to be talking sensibly; there was no attempt at unction such as you see among the Roman Catholic ecclesiastics. The audience were very attentive and occasionally joined in some kind of response. Remembering that in their way they were worshipping God, I felt unwilling to keep my hat on, but they would have thought it disrespectful to have taken it off.[149]

His observations do not pretend to be anything more than brief impressions of a culture that was clearly alien to him. Half-entranced, half-horrified by what he saw in urban Istanbul, he was simply a Briton busy on a mission elsewhere, taking the few days to see a principal sight or two and shop for souvenirs. He was mindful of local customs, at least when they involved religious observances, the impulse of which, if not the belief, he obviously approved. That he went so far as to prefer the unpretentious manner of an Arab preacher to that of an unctuous Roman Catholic priest is somewhat surprising, but then Fenton was a liberal from Lancashire. Although he must have felt culturally superior, his words do not reek of condescension, and visually he was wholly open to the beauty he saw, as in the scenery that unfolded on his passage through the Sea of Marmara and out into the Black Sea.[150] After these first few letters en route, the rest are written from the Crimea itself and are concerned with the war, the men and officers he met, his adventures and mishaps, and the difficulties of making photographs in a war zone and a hostile climate. The later letters do not touch on local culture, caught up as he was in a nearly unprecedented endeavor, capturing a military campaign with a camera.

Given the multinational composition of the allied expeditionary force in the Crimean peninsula, the ethnic diversity of the citizenry of the Ottoman Empire, and the fact that at this period in the nineteenth century military uniforms were not yet standardized, the troops themselves made up a colorful panoply that Fenton took some delight in recording [FIGURES 42–43]. His photographs of members of individual military units of the French army, distinguished by their unusual uniforms, and Turkish nationals from various regions constitute his first images of the exotic. These pictures of Zouaves, Spahis, Nubians, Tartars, Chasseurs d'Afrique, Montenegrins, Egyptians, and Croats foreshadow his use of costume in the Orientalist photographs. They constitute, with his extended series of portraits

76

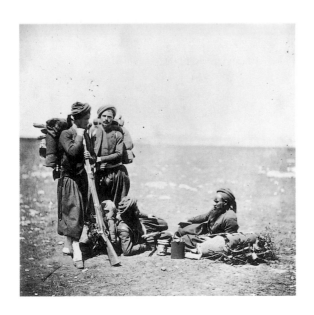 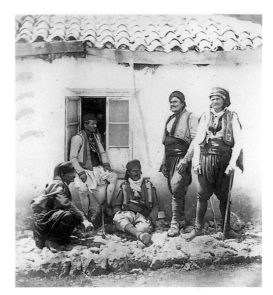

Figure 42
Roger Fenton.
Zouaves, 1855. Salt
print, 15.4 × 15.6 cm
(6¹/₁₆ × 6¹/₈ in.).
Los Angeles, J. Paul
Getty Museum.

Figure 43
Roger Fenton.
Group of Montenegrins,
1855. Salt print, 18.2 ×
16.4 cm (7³/₁₆ × 6¹/₂ in.).
Los Angeles, J. Paul
Getty Museum.

of British officers and soldiers, whether taken in the open or in his improvised studio, his most significant body of work dealing with the human figure, whether at a distance in the case of the groups, or close in, as with the individuals.

When he came to make his Orientalist studies in his London studio three years later he would have, of course, considerably more latitude in the posing of figures, as his models would not only be at his disposal to arrange as he saw fit, but also were not freighted with the gravitas of war. In fact, the expressions of surprisingly few of the Crimean sitters are gravely serious except for the generals of the highest rank, and they presumably felt compelled to demonstrate the weight of their responsibilities for Fenton's camera, aware that their portraits would be studied by the British public and their sovereign. In his double portrait of the attendants of Marshal Pellisier, the Zouave lounging on the steps has felt no such restraint, but Zouaves had a reputation for unconventional behavior [FIGURE 44].[151] His posture sharply contrasts with the upright nobility of the Arab chief in Fenton's full-length portrait of a man bedecked for war [FIGURE 45].

Fenton's audience shared his interest in the unfamiliar. When the photograph of the attendants of Marshal Pelissier was exhibited in London a reviewer condescendingly distinguished the two men: "... the one, half an Arab, with long

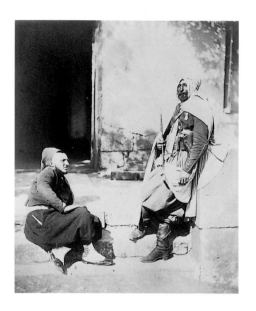

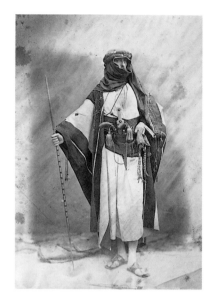

cloak and hood, and the other the orientalized Frenchman, the modern Turk in body, the ancient Turk in soul, needing no hope of houris to lead him to the breach and satisfied with one heaven instead of seven." [152]

It is the memory of the Zouave's pose, and of others he saw adopted by persons less accustomed to chairs than Western Europeans, that Fenton would bring to bear on the staging of his Orientalist pictures. Those pictures must also, however, be somewhat dependent on what one supposes he heard around dinner tables and campfires in the Crimea about Turkish life. Fenton was evidently a very agreeable dinner companion (and, as his letters make clear, far from indifferent to food or drink) and was consistently invited to dinner and housed for varying periods by French and British generals. Surely not all of the conversation can have been limited to the progress of what was in the spring and early summer of 1855 a nearly stalemated war.

Aside from the requisite portraits of the higher echelons of the allied armies, it was Fenton's choice as to whom he wanted to photograph. The soldiers were more than willing models; their requests to have their likenesses taken were troublesome to fulfill and their trade was not of interest to Fenton. [153] On the other hand, such portraits as that of the Arab chieftain typify the allure of the exotic,

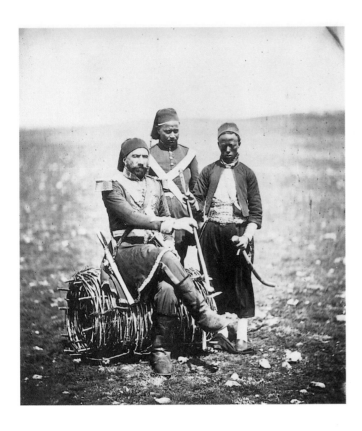

Figure 46
Roger Fenton.
Ismail Pasha and Atten-
dants, 1855. Salt print,
18.1 × 15.6 cm (7⅛ ×
6⅛ in.). Los Angeles,
J. Paul Getty Museum.

which might prove to be attractive to the picture-buying public. It was not a long step from the production of images of real Turks and the like to his Orientalist photographs of three years later.

 As a specific instance of the formative nature of this exposure to the Near East on his later pictures, it is clear that Fenton's idea of the importance of the chibouk and the smoking of tobacco derive directly from the Crimea. He made two photographs there of the Egyptian general in the Turkish army Ismail Pasha and his attendants. In one the caption tells us that he is calling for his chibouk, and in the other a man whom Fenton referred to as the pasha's Coptic pipe-bearer is in the process of handing it to him [FIGURE 46].[154] Seated on a gabion, a wicker form intended to be filled with earth or rock and used as a defensive barricade, the pasha good-naturedly poses for the camera, dressed in a uniform that is nearly wholly European save for his tasseled fez. He sits upright with his knees

79

crossed, a European pose at odds with the ceremonial presentation of his pipe. In some ways he is a man caught between two cultures, but it is his less-familiar Near Eastern aspect that Fenton has found of interest and has photographed.

Before leaving the Crimean pictures, there is one extraordinary photograph that needs consideration [FIGURE 47], although it is not altogether clear that it was made by Fenton.[155] One would like to say that this image of a scribe was made in Constantinople itself, but the bulk of Fenton's photographic equipment, if not his cameras, was stowed in the hold of the ship during his five-day stopover there on the voyage out. Presumably the same was also true on his return trip, but in any case he was far too weak from the cholera he had just contracted to have been able to make photographs. He was not, however, too ill to write letters and perhaps have a last chance at shopping. He could also have sent his servant William or his assistant Marcus Sparling in search of last-minute souvenirs that would later be pressed into service in the Orientalist pictures.

Perhaps this photograph was made in the Crimea itself, although the splendid large-scale garden-pattern carpet does not figure in any of the other portraits made there, but neither is it visible in any of the photographs made in Fenton's London studio. The utterly plain backdrop is equally unfamiliar. The most persuasive reason for thinking the image to have been made in the Near East and thus to predate the balance of the Fenton photographs with superficially similar subjects is that the scribe himself seems so authentic. Unlike the models in the Orientalist photographs by Fenton (and by Grundy), his facial features and coloring are not British. His physiognomy is as appropriate as his clothes, and his posture is particularly telling. The way he sits with pad on knee and poised pen is quintessentially non-European, the manifestation of a habitual way of sitting on the floor when writing. The details, such as the beads around his neck and his box of writing implements, also seem right. His bare toes seem grimy, as if he had left his sandals at the edge of the rug after walking some distance outdoors. He looks up to the camera steadily but warily. The portrait is a specific and respectful study of an individual, delineating vocation and character, an exception to Edward Said's insistence that one looks in vain in Orientalist works for a lively sense of the human or social reality of an individual Near Easterner.[156] Regrettably, we know

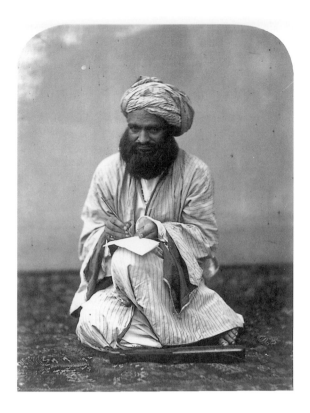

nothing about the circumstances in which it was made.

 A minor prefiguration of Fenton's production of Orientalist imagery is a photograph that he made about 1856 in the course of his work documenting some of the collections of the British Museum. His most notable work for that institution is the large number of studies he made of antique sculpture, but he also photographed many drawings in its collection, including work by Raphael, Leonardo da Vinci, and the Venetian painter Gentile Bellini (1429–1507).[157] Bellini's sojourn in Constantinople in 1479 and 1480 at the court of Sultan Mohammed II gave rise to a number of drawings and paintings [FIGURE 48]. This crystalline drawing of a Turkish woman sitting cross-legged on the floor—there is a pendant of a seated man, which Fenton also photographed—is one of those the artist made to record local costume, custom, and color. Its unforced presentation of a directly

Figure 47
Attributed to Roger Fenton. *Turkish Scribe*, ca. 1855. Albumen print, 21.8 × 16.5 cm (8⁹⁄₁₆ × 6½ in.). Bath, The Royal Photographic Society.

Figure 48
Roger Fenton.
*Gentile Bellini's "Turkish
Woman"*, ca. 1856. Salt
print, 21 × 16.9 cm
(8⁵/₁₆ × 6¹¹/₁₆ in.).
Los Angeles, J. Paul
Getty Museum.

observed reality and the isolation of the figure from any context reinforces its exemption from the category of the imagined Orient and makes it more simply an eloquent statement of its own.

Two portraits by Fenton of the celebrated Italian tragedienne Adelaide Ristori (1822–1906) in the title role of Schiller's Mary Stuart, made about the same period as the Orientalist suite, have as vital components the same theatricality and costuming that characterize that series. As studies of an actress in a role, neither is a portrait of the actual woman nor of the dead queen, but rather a hybrid, an impression of an impression of character. These two images are among the few surviving studies of an identified civilian sitter, not made by Fenton in the Crimea, and the only ones in which his subject is playing a named role in a formally scripted performance, although the precise juncture of word and moment is unspecified.[158]

Fenton's interests in staged tableaux, exotic costume, and theatricality would fuse in his production of the images in the Orientalist suite.

THE ORIENTALIST SUITE
AND ITS CRITICAL RECEPTION

Fenton first exhibited photographs from the Orientalist suite at the late 1858 exhibition of the Photographic Society of Scotland, but they comprised only three of the fifty pictures he showed. While testing the acceptance of this new series of images, he took care to safeguard his existing artistic reputation by continuing to show landscapes and architectural studies. The three newly made Orientalist pictures he exhibited in Scotland were titled *Pasha and Dancing Girl* [FIGURE 1], *The Water Carrier* [FIGURE 21], and *Turk and Arab* (which can probably be identified with FIGURE 10).[159]

 A month later, in January 1859, the sixth annual exhibition of the Photographic Society opened in London, a more important venue to Fenton because more of his peers were in England, the London exhibition would have more extensive press coverage, and the London market was larger than that in Edinburgh. Critical reaction to his new field of endeavor was somewhat mixed, although generally favorable. The photographs were praised, but not as highly as his work in landscape and architecture. What was said about the Orientalist images is highly revelatory and deserves extended examination.[160]

 Fenton submitted to the London exhibition forty-two photographs, of which eight were Orientalist pictures, although two of the catalogue titles are now difficult to associate with specific surviving photographs. Of the eight, one was an image that he had shown in Scotland with a different title. In the London exhibition the woman undulating before the pasha became something more poetic and exotic, a *bayadère* rather than a mere dancing girl, and the title: *Pasha and Bayadère*.[161] A photograph of a water carrier was apparently a variant of that shown in Scotland, as indicated by the addition of the word *Nubian* to its title.[162] The Turk and Arab did not reappear, but in their stead were *Turkish Musicians and Dancing Girl*; *In the Name of the Prophet, Alms*; *Egyptian Dancing Girl*; and *The Reverie*. The price for each was seven shillings, sixpence.

The image called *Turkish Musicians and Dancing Girl* is a variant of *Pasha and Bayadère* in which the dancer has pivoted forty-five degrees toward the camera, the stringed-instrument player has moved to the couch and now plays a reed instrument, the pasha is no longer present, and another man has replaced the first on the floor to play the spiked fiddle.[163] *In the Name of the Prophet, Alms* seems to be a photograph that includes Fenton's principal and ever-patient female model, this time standing with a woven container dangling from one hand while she witnesses one man (the former fiddle player in a different guise) asking another for alms [FIGURE 49]. The omnipresent pipe is again used as a diagonal, leading from the hand of the seated man to the foot of the woman, and the water jug has come to rest less prominently on the floor at right. A different rug has been laid across the scene, and there are perhaps too many slippers on the floor between the actors to fit the scenario, as presumably the sitting man wears only two shoes at a time and three are present. The third may be left from an earlier photograph when the beggar took another role.

A significant addition to the roster in terms of the critical attention it was to attract was *Egyptian Dancing Girl* [FIGURE 50]. It is once again the compliant model, again in a dancing pose, but unaided by wires and more directly addressing the camera. At left there is just enough of a fiddler's knee and instrument to make it clear that she is a dancer. Because of the long exposure, perhaps as much as three seconds, her fingers have trembled enough to cause the finger cymbals to blur. Among the signifying props are the lozenged table, a nargileh, a chibouk, and a feather whisk. She stands once more on the western Anatolian village prayer carpet that appears often in these photographs.[164] She has transmogrified, however, in a short distance along the wall of the gallery, from representing a Nubian to impersonating an Egyptian, and she will change again when her image is exhibited in Paris in April of 1859 under the title *Jeune fille bohémienne dansant*.[165]

The reviewer for the *Athenaeum* managed to notice five of Fenton's pictures in his review and singled out the same image of the dancer for praise:

> Though mellowed by the dimness of Eastern interiors, nothing can surpass Mr. Roger Fenton's Eastern characters, which convince us that we want new Arabian Nights, and some Eastern painters newer

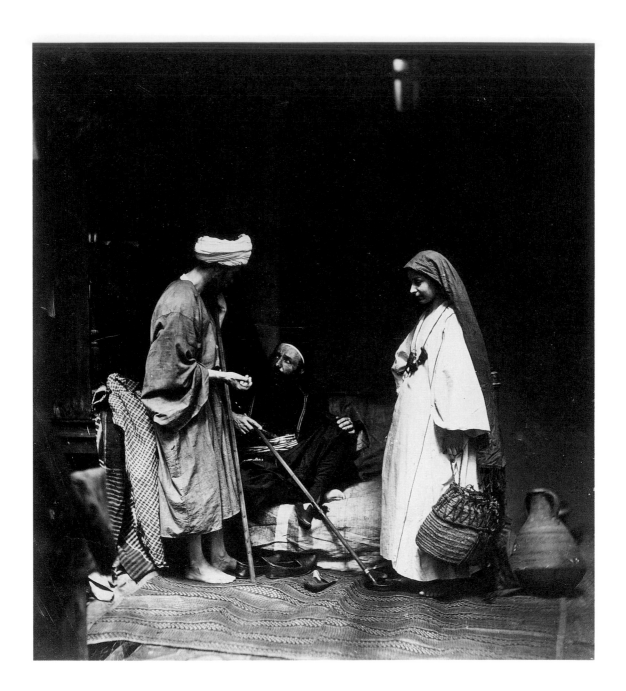

and nearer our own day. The *Nubian Water-Carrier* is the serf-like, patient woman of the old servile type, with the talisman on her bare breast, and the huge jar poised on her head, as if she was [*sic*] one of the Caryatides that Athenian sculptors used to poise up on their roofages. *In the Name of the Prophet, Alms* (617), the Turk's look of wonderful hard contempt is caught by a wonderful flying shot; and then the *Egyptian Dancing Girl* (621) the bayadere is a beautiful example of voluptuous, tranquil beauty, as she stands with the row of dangling gold coins round her brow, and the flower-like castanets pendent from her lithe fingers. The mouth and eyes are of the tenderest and most siren-like grace; yet, for muscular expression we prefer not the stolid, slow-kindling admiration and enthrallment of the Turkish listener so much as the faces of the *Musicians* (606), with the curious spit and stewpan instrument and the double flute. The matting, the lozenged water-jar, the brushes, and other stray litter of the room are especially Eastern, and heighten the effect.[166]

(In his line about enthrallment he refers first to *Pasha and Bayadère*, which he does not name but indicates by the reference to the staring man, and then to *Musicians and Dancing Girl*, which he prefers.)

Aside from the fact that the reviewer seems overly eager to be indulged in the fantasies that he saw portrayed, which is not insignificant in itself, his words indicate not only aspects of how these pictures were seen but how they were intended to be seen. His reference to the "old servile type" of woman is appropriate not only for the water bearer but for other poses in which Fenton has depicted women, including holding fires to light men's pipes, abjectly crouching at their feet, and dancing. Women in this and nearly all Orientalizing fantasies are meant to serve and to please men. When they are not objects of delectation, they are models of subservience. The reference to her talisman is likely pejorative, pointing to her supposedly superstitious nature. The reviewer implies that there is a newer type of woman, presumably a modern Victorian (and Christian) woman, but does not specify her attributes.

He has saved his real admiration for the Egyptian dancing girl [FIGURE 50]. The appreciative terms he employs—"voluptuous, tranquil, lithe, of the tenderest" and "siren-like"—form a virtual catalogue not only of her endearments

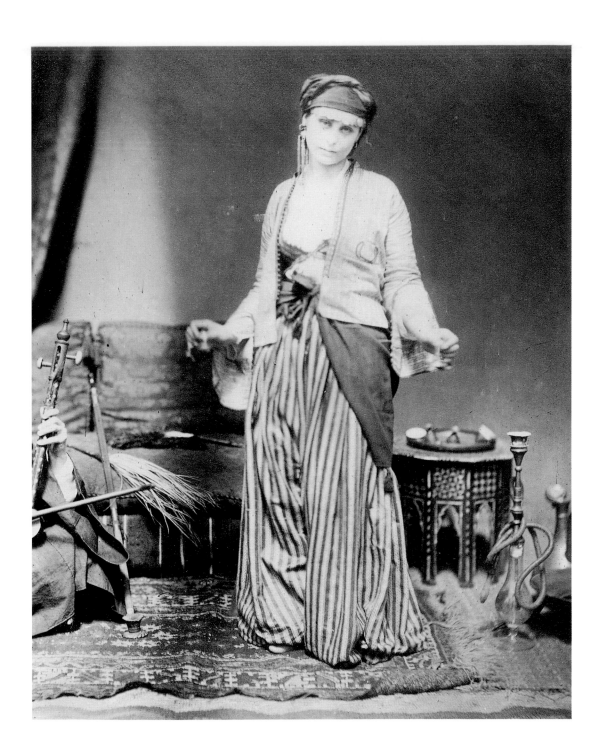

but also of the stereotypes of Orientalist misperceptions, lacking only idleness and perhaps cruelty, although even that is implied in "siren-like," destroying as they did the men who ventured too close. That he uses this kind of language reflects his, and the society's, willingness to accept this idea of the degraded status of women in both the fantasy world of the Near East and, to an appreciably lesser extent, the European world. This particular viewer exemplarizes conventional thought about the Near Eastern world and its evident temptations. By making these photographs Fenton indulged and embodied these same attitudes.[167]

This reviewer's call for "newer" and "nearer" Eastern pictures is a seeming rejection of the earlier work of David Roberts and the like, but it is also a plea for more modern painting and is perhaps by implication a reaction against the formulaic themes of history paintings of the period. All of this points to painting as the origin of Orientalist photography, although literature is also invoked. The critic's call was not to go unheeded long. In the next several years Goodall, Dillon, and to some extent, Hunt would amply answer his request.

The *Athenaeum* reviewer was not alone in appreciating the dancing girl; after commending Fenton's landscapes, a somewhat skeptical reviewer for the *Art Journal* continued:

> We do not so much admire Mr. Fenton's Egyptian figures. His Nubian Water-carrier is statuesque and beautiful. One of his Danc-ing Girls has a strange quiet—an oriental dreamy air; but valuable as all of these pictures are, as truly representing some phases in the life of this interesting people, we cannot regard them as a success.[168]

One is somewhat at a loss to know exactly which people this critic thought the pictures represented, Nubians, Egyptians, or Turks, but he seems to have had no doubt that someone real was being represented. He may have elided all the inhabi-tants of the Near East, as Fenton himself seems to have done in the vagaries of his titling, grouping them all simply as someone "other," the principal characteristic, as Said is famous for pointing out, of the normal Western way of looking at the East. Regrettably, he did not elaborate on what it was that made these pictures fail-ures in his eyes.

The *Egyptian Dancing Girl* also underwent a change of title, being dubbed simply *Arab Costume* when Frith—who had purchased this and other Fenton negatives in 1862—printed this image and captioned it on the mount, along with a credit to Fenton. Since then the picture has generally been known by this title. Her evident popularity is also vouched for by the fact that there are four surviving prints of this image, more than any other from the Orientalist suite.

A reviewer for the *Photographic Journal* was more favorably disposed:

> we are pleased to notice that he [Fenton] is turning his attention to a department of the "art" in which he is less known than in his exquisite landscapes—we mean those subjects that in *art-slang* are generally designated as *genre* subjects. Of these, No. 43, *The Pasha and Bayadere*—No. 50, *The Reverie*—No. 606, *Turkish Musicians and Dancing Girl*—No. 608, *Nubian Water Carrier*, are favourable examples, being admirable illustrations of Eastern scenes of actual life. Their execution, also, is worthy of Mr. Fenton's well-known fame.[169]

There is an underlying assumption in this paragraph that within the fictional framework that genre art implies, the pictures can be filled with truthful detail. The normal presumption of the period, that one of the virtues of photography was its fidelity to life, has been subordinated to an overriding artistic intention and enlisted to flesh out that intention. This double role is at least theoretically contradictory, a problem in Victorian aesthetics to which other commentators of the time would allude.[170] None of these writers suggested that Fenton made these photographs during his Crimean expedition.

A reviewer from the *Daily News* specifically compared one of the other Orientalist pictures to the standard-setting work of John Frederick Lewis, saying, "In *The Reverie*, for example, we have more than all the detail of a water-colour drawing by John Lewis, and at the same time a low tone of singular breadth and sweetness."[171] It is not now possible to connect this title to a specific image in the Orientalist series as the title could be applied to several, including the image of the reclining odalisque [FIGURE 17]. More likely it belongs to one of four other pictures of the same sitter in a more upright pose [FIGURE 51]. Because of the model's gentle

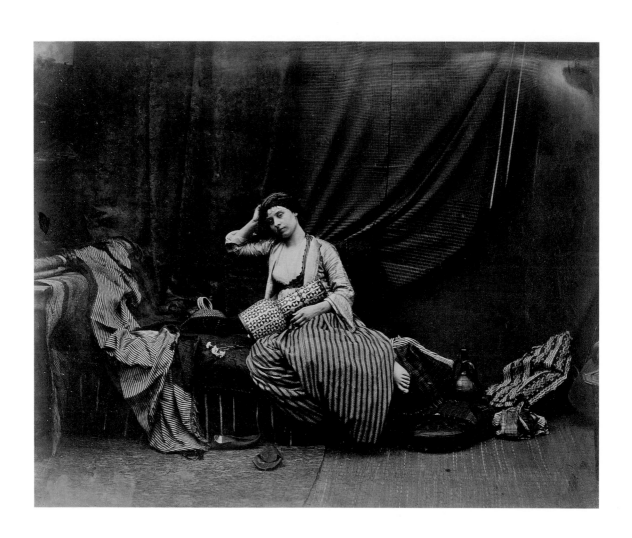

expression the photograph illustrated here seems the most appropriate for this title. In each of the variants the pose changed and the subsidiary properties and draperies were rearranged, however slightly. In the most subtle instance the only differences were that the background brocaded curtain was opened more fully, a sprig of blossoms was added on the divan, and the drum was shifted from the model's lap to her side. In other words, Fenton was not content just to ask the woman simply to shift pose, to express reverie by putting hand to brow, but constantly restudied his composition in the ground glass of his camera, relentlessly seeking to perfect his picture. This long bout of working before the camera took its toll on his model. In what one assumes may have been the last of the photographs that might have been called *Reverie* she appears exhausted rather than contemplative.[172]

It is somewhat difficult to fix with certainty the last two photographs that Fenton showed in January 1859. Their titles were *Returning from the Well* and *The Barbarian Captive*. The first of these could conceivably be identified with the *Water Carrier*, rather than the *Nubian Water Carrier*, which was specifically named as being in the exhibition, except that it is hardly likely that Fenton would have chosen to place such similar photographs in the same exhibition. Among other things it would have pointed up his fanciful titling. It is more likely to have been an image in which a veiled standing woman holds a water jug at her side.[173]

The last title, *Barbarian Captive*, can be assigned with some assurance to an image that is otherwise hard to interpret [FIGURE 52]. The wholly abject posture of the woman in this photograph is consonant with an idea of captivity, even if less so with barbarism. This time the model is nearly wholly covered by her head shawl except for the tip of one foot, a hand, and a portion of her profile. The man's face is scarcely more visible and domination is conveyed by the fact that he stands over her looking down, and that he holds in his left hand some long tubular metallic object that can perhaps be taken as representing, imprecisely, an instrument of discipline or order. Without a title this image is puzzling, conveying an uneasy feeling of physical or psychological threat, but the addition of a title makes it hardly more satisfactory. It is not surprising that the periodical critics of 1859 chose to pass over this picture without comment.

Figure 51
Roger Fenton.
Contemplative Odal-isque, 1858. Albumen print, 36.2 × 43.8 cm (14¼ × 17¼ in.). Los Angeles, J. Paul Getty Museum. Gift of Professors Joseph and Elaine Monsen.

Figure 52
Roger Fenton.
Barbarian Captive, 1858.
Salt print, 35.5 × 26.1
cm (14 × 10¹¹⁄₁₆ in.).
Los Angeles, J. Paul
Getty Museum.

The most specifically pointed criticism of these pictures appeared in a review in the *Photographic News*, leveling some of the same objections that might occur to a modern viewer. After a discussion of the problems of the literal representation of reality in photography, whether in pictures made from composite negatives or in genre works from single negatives, the reviewer condemned specimens of the latter made by the Truefit brothers for asking uneducated children to assume "a class of sentiment which it is impossible for them to understand or appreciate." [174] "Maudlin stupidity" is the result of *"poses* and arrangements of figures . . . more like bad stage conceptions than scenes from actual country life." [175] The writer mentioned the importance of titling to the interpretation of

the images and the necessity for having "real artists to conceive and work out the arrangements." He continued with a series of remarks that bring forward some of the most essential considerations about Orientalist photographs in general and the *Pasha and Bayadère* in particular:

> Fenton has been tempted into this department [genre photography], and, for a "first appearance," his pictures are not so bad, still they are not such as please us. With regard to the arrangement of dress and interior detail, there can be no doubt that Fenton is the one who ought to be well able to give us a correct idea of the household economy of the Orientals. Still there is one thing which does much to spoil the whole of these studies, and that is what we have repeatedly urged on those photographers who attempt to illustrate eastern manners and customs, viz: the necessity of having real national types as models. If these compositions are to be of any use, let us at least have associated with the dress the physical characteristics of the nation; and let the physiologist have equal chance with the *costumier*. In the very clever photographs of Turkish character, which W. M. Grundy exhibited some time ago, the very same defects were apparent that are to be seen in Fenton's pictures. In these pictures Fenton has not succeeded in overcoming the difficulty of copying from expressionless models—a difficulty to which we have often alluded in connection with this subject. A most amusing circumstance, in connection with his picture of the "Pasha and Bayadere" (46), is the fact that one of the "tricks" which enables the composer to produce an effect is too palpable If the visitor will very closely inspect this picture, he will find that the strings, which are intended to hold up the hands of the female figure, are plainly to be seen. This is a peculiar defect in many of Fenton's compositions: the figures have not been able to keep their hands quite still while the picture was being taken. In the picture "Returning from the Fountain" (59), everything has been sacrificed, as far as background effect goes, in order to catch the figure. This is to be regretted, as it spoils the picture. "Nubian Water Carrier" (608) is the best of these series, the only defect is a little mistiness about the hands; altogether we many congratulate Mr. Fenton on his first attempts.[176]

This critic, by far the most specific and severe, is troubled by the apparent visual inconsistencies in the photographs that make it clear that these tableaux were specifically staged for the camera. He acknowledges that artifice, such as the overhead wires, can produce an effect, but the trick must not show lest it undermine the "willing suspension of disbelief" as much it disturbs the usual presumption that photography presents a truthful rendering of unmediated reality. His commonsensical objection to the models' physical appearances points out another discrepancy, although it is an open question whether more appropriate faces might have carried conviction that the camera could convey.

A supplier of costumes is seen as an inevitable necessity, but there seems to be no sense here that the clothes themselves must be worn by persons habituated to wearing garments of particular types, that our dress makes a difference to how we can and do behave, as well as to how we look. For example, the crinolines just coming into fashion when these photographs were made would make it impossible for a Victorian woman to sit on a couch without a careful preliminary adjustment of her skirts. Similarly, a veiled Turkish woman probably had little peripheral vision even if her trousers gave her greater freedom of movement, at least indoors, compared to her British contemporary. Clothing determines possible postures and habits. In short, had actual Turkish persons posed for such a scene it would have affected its appearance far more than this reviewer suspected.

The *Photographic News* critic also seems willing to assume that the costumes presented were what Near Easterners actually wore. Generically the clothes are accurate in Fenton's Orientalist photographs, but close examination also shows that they are a pastiche in that elements of different regional clothing have been somewhat haphazardly assembled to produce these outfits.[177] They are indeed costumes. The bayadère's clothing is not really that of a dancer; the sleeves of her jacket are so constricting that they had to be left unbuttoned, and for a dancer she wears far too little jewelry. The men's garments are similarly inconsistent.

Within the Orientalist suite there are, however, a few exceptions to the improvised costumes that most of the models wore. These more coherent outfits are worn by a man and woman who figure, usually together, in six of the images in this series, none of which was exhibited in 1859 [FIGURE 53]. Their clothes are more elaborately cut and shaped than those seen on the other models and are made of

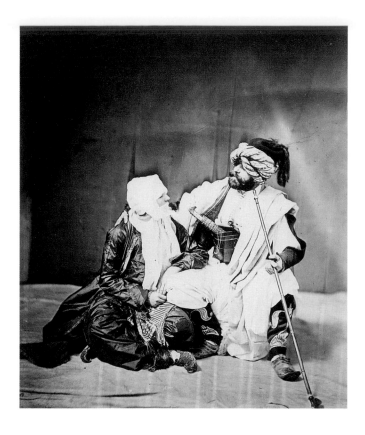

more expensive materials. The man's clothes are those of an Egyptian of rank of the first half of the nineteenth century, although he himself is a northern European. Not the usual female model, the woman is of equal rank and she is always veiled. (Although she is very likely merely enjoying the masquerade, an interesting transposition of cultural prohibitions could be present if her insistence on remaining veiled occurred out of modesty or to avoid the stigma of being thought a professional model.) As with Fenton's other models this couple is an instance of disguise, of veils and screens as persons take on other identities. From the intimacy of this pose, which would have been unthinkable for a real Near Eastern couple to assume in public or for the camera, we can assume that they were married.

Although the photographs of these two people stem from some of the same set of impulses as the rest of the suite, they have a simpler setting and lack

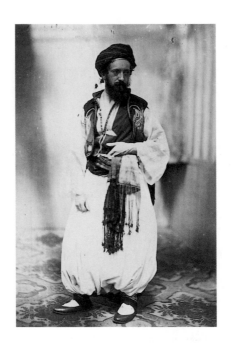

Figure 54
Roger Fenton.
Costume Study, 1858.
Albumen print, 25.6 ×
17.1 cm (10¹/₁₆ ×
6¾ in.). Los Angeles,
J. Paul Getty Museum.

storytelling content. In the images in which they figure there are no accessories except for a chibouk and no furniture other than a European footstool on which she rests a foot in one image and a chair on which each of them sits in turn. The background is either the plain back wall of the studio or a large boldly striped drapery swung asymmetrically across it. A supposition is that once Fenton had embarked on his series of pictures of Orientalist scenes and had spoken of the venture to his friends, these two people, who already owned appropriate fancy dress, perhaps as a result of a trip to the region, volunteered to pose.

An equal lack of Orientalized setting and accessories characterize two photographs of a standing man [FIGURE 54]. Although the clothing appears authentically Turkish, the uncamouflaged studio carpet at his feet is plainly European and his shoes seem similarly suspect. These two images are so straightforward that they must be considered costume studies rather than genre pieces. This model does appear in some of the storytelling pictures, but wearing different clothing. Like the photographs of the couple in fancy dress there is no record of these two photographs ever being exhibited.

In the *Photographic News* review there was also an (unwarranted) assumption that Fenton's Near Eastern experiences had given him greater access to the private lives of its peoples, and also that the essence of Near Eastern life could be conveyed by a camera. Ideally, the reviewer wanted these compositions to be "of use" (which probably simply means "of value"), although to whom is unstated.

A modern viewer of these photographs looks at them from a different perspective than that of the reviewer. The fact that a hand has moved in the course of an exposure is not necessarily a fault, merely a trace of the temporal condition of the making of a photograph, but hardly an impairment of its "utility," unless an artist seeks to draw from it the precise position of fingers. To impose completely stopped motion on a photograph as a condition of excellence in 1859 was to borrow, once again, the standards of painting for judgment, not entirely inappropriately perhaps, as it is to be like painting that these photographs aspire. Despite Fenton's work on the negative of *Pasha and Bayadère* to conceal the strings that held the dancing girl's hands in position, the sharp-eyed critic spotted them. She could hardly be caught in the midst of a dance if her arms were immobilized by wires. The artifice is all too plain. She is not dancing but posing. Fenton's decision to continue to exhibit this photograph in the face of criticism like this indicates that he must have thought that it had compensatory virtues. The cleverness of having thought of wires to hold her hands had produced a visible defect, but to have captured her posture at all was an overriding achievement. For other exhibitions he probably cropped the picture vertically so that less of the offending wires showed.[178] Perhaps he felt that of his works this picture epitomized the Orientalist image.

The last salient criticism of the newspaper reviewer, who in his reference to Grundy recognized the lineage of these pictures, was that the models' faces were too often expressionless. This was not the result of the actors being asked to play roles they could not understand or express, but rather that the roles were underwritten, i.e., that in many of these scenes only an action is being mimed rather than a story told. Although we lack the captions for many of these photographs that might give them greater complexity, the likelihood is that the content of many of these images was as simple as that in *Turk and Arab* [FIGURE 10], which really shows us no more than a difference between two approximations of regional costume. There is, in short, no emotion being expressed, only a compari-

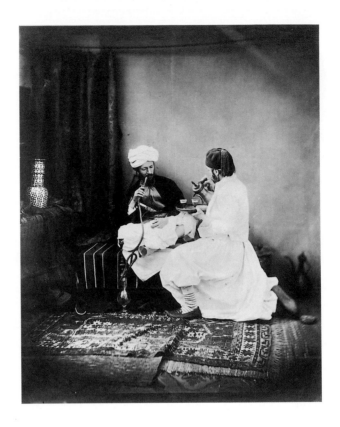

son made, as in the photograph that shows a serving man, down on one knee, pouring coffee for a man who sits smoking on the low couch [FIGURE 55]. The assumption that the former is a servant is perhaps belied by the two cups on the tray, but the comparison is not really between the status of master and servant but between how this kind of scene looks, or more accurately, is imagined to look, in the Islamic world and how a similar scene would look in England. It is easy to forget that servants were part of ordinary life in Victorian England. Fenton himself employed at least three at home and his audience would have done similarly. Subservience is as consistent an element of content in these pictures as is that of an imagined domesticity of scale and occurrence. It might be added that even if there is not much expression present on the faces of the models, particularly in the unexhibited photographs, there is an overall impression of good-humored play-acting that takes these views close to the parlor tableau.

The peculiar, almost claustrophobic environment in which all these scenes are laid—a proscenium framed by the picture's edges, a shallow stage with neither window nor door—leads to a feeling of intimate engagement with the persons represented and gives them much of their uncanny power, however factually awry they are. Any viewer is pressed close to these people, whether they be Turkish or British, and this may account for the disproportionate amount of attention that these photographs were given in the press of 1859 by comparison with the work of other photographers. It was not simply that Fenton deserved attention as an acknowledged master of landscape photography and a presumed authority on the Near East because of his groundbreaking presentation of the Crimean war, but that the photographs themselves compelled it. Their subject matter was exotically, and in some instances erotically, attractive; they were thought to be genuinely informative; and in the majority of the examples that were exhibited, they were imbued with enough of the narrative content beloved and expected by audiences of the time to conform to expectations for publicly exhibited art, including fledgling photography. It was surely Fenton's desire to fulfill those expectations as he endeavored to raise the status of photography into at least the lower rank in the hierarchy of the art of the time, genre subjects. He would take this effort further in the following summer, by his wholehearted pursuit with the camera of still life as a class of subject. He would then fall back from storming the barricades that the art establishment had thrown up against photography, this newcomer in the streets, and retreat into the relative tranquility of the law, having done more than any other man of his generation to advance the cause.

May and June 1858, when Fenton's consistent attendance at council meetings of the Photographic Society show him to have been steadily in London, must have had a fair proportion of clear days. Sunny skies brought abundant light through the overhead glass of the studio Fenton had built in 1857 at his house in Albert Terrace, perhaps on the top of the house, but more likely in the buildings at the rear of the property.[179] Good weather for indoor photography. Fenton had an idea about a new subject for photographs he wanted to make. Influenced by Delacroix, Moulin, Tennyson, Lewis, Grundy, Haag, others whose names we guess and some we do

not know, he wished to try his hand at Orientalism. Remembering the glimpses of life he had seen in Malta, Constantinople, and the Crimea three summers before, he had brought into the studio everything in the house that reminded him of those places—furniture and draperies, rugs and objects, costumes and ornaments, things he had bought and borrowed. He had asked a few of his friends to come and help, to pose, to sit cross-legged on the floor and pretend to draw on pipes. The manservant, too, the one who doubled as a studio assistant, had been pressed into service, asked to put on these peculiar loose-fitting clothes in which a man felt hardly dressed. And the woman, the broad-cheekboned woman, the artist's model with infinite patience, she too changed her clothes repeatedly at Fenton's direction, sat on the floor, moved to the couch, sat up, lay down, pretended to light pipes, held a jug over her head, mimicked an Oriental dance with hands uncomfortably held overhead by strings that bit the wrists. Over the course of the week or two the weather stayed warm and they found it wasn't uncomfortable being barefoot, sitting still, and besides it was fun stepping out of one's normal life, pretending to be someone else whose life involved little more than lying about, conversing, drinking coffee, smoking tobacco, playing instruments, and watching the woman.

The studio had never been so busy. People came and went on different days, new people in different clothes, and they too played this game for which only the ringmaster knew the rules. Yes, Fenton—always moving about, constantly changing the positions of the objects, adjusting the screens on the skylights, plumping the cushions, covering the couch with a different swath of material, relentlessly making suggestions, giving directions, asking questions, and when everything was arranged to his satisfaction, disappearing for a little while to return carrying the damp collodion-covered glass plate to the camera, and after the exposure during which everyone had to be perfectly still, taking the plate away again. Peering, always peering into the back of the camera to see what the scenes in front of it looked like, staring at the others, moving them back and forth, playing them like instruments in search of melodies that only he could hear. And when it was done and the days had past and all the fifty pictures were made and everyone was ready to go, she asked, the dark-eyed woman, now that she was once again in her street clothes, for one more, for a last photograph to show her as she really was, for something she could take home to her family. And he said yes.

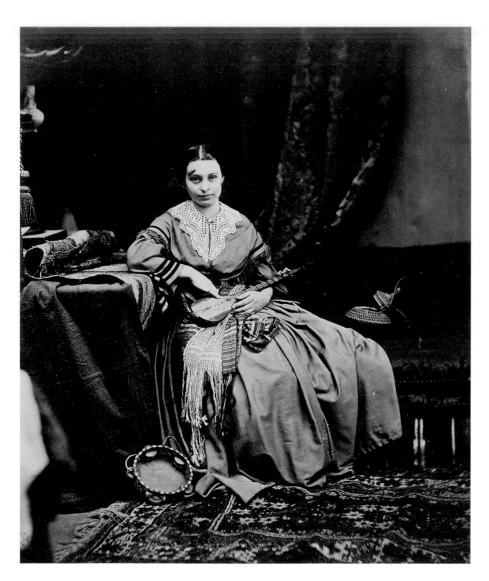

Figure 56
Roger Fenton.
The Patient Model,
1858. Albumen
print, 23.4 × 19.5 cm
(9 3/16 × 7 11/16 in.).
Topanga, Michael
Wilson Collection.

NOTES

1 For two illustrations of nineteenth-century
installations of pictures see Mark Haworth-
Booth, *Camille Silvy: River Scene, France*
(Malibu, 1992), p. 13.

2 It is all but certain that this caption was
applied to this image. Of the fifty or so Orien-
talist images that Fenton made and that we
now have, this title could only logically have
applied to this picture.

3 Admittedly a Victorian might have been
unlikely to use the word hips, but it should
be remembered that Victorian attitudes
stiffened as the reign wore on and were
easier in the 1850s than in the 1870s.

4 As an example of the confusion, one of
Fenton's studies of a dancing girl arrived in
the collection where it is now housed from
another collection, where it had been filed
under "Types, Hebrew," and credited to
Mayall.

5 The consignor has preferred to remain anony-
mous but has said that according to family tra-
dition his ancestor acquired the albums as
collateral for a loan made to Fenton that was
never repaid. Lindsey Stewart of Christie's,
London, was kind enough to obtain this
provenance. One would not have thought
Fenton ever so much in need of money, nor a
studio scrapbook appropriate collateral. Is it
possible that if there was a loan, it was made
after his death to Mrs. Fenton, who judging
from her sale of his collections and their
house may have been in need of funds?

6 Among the easily identified sitters are Gari-
baldi, Carlyle, Dickens, Lincoln, Seward, and
any number of actors and actresses. The large
number of cartes-de-visite, which were most
popular in the 1860s, suggests additions to the
albums after Fenton had given up photogra-
phy. Smaller format pictures seem to have

been arranged around the larger images or
placed on later pages in the albums. The
residue of these albums is now in the Getty
collection.

7 There are two standard references for Fen-
ton's life. The first is Helmut and Alison
Gernsheim's *Roger Fenton, Photographer of the
Crimean War* (London, 1954), in which a text of
thirty pages is followed by a selection of plates
and seventy pages of Fenton's letters from the
Crimea to his family and his publisher. The
second is John Hannavy's biography, *Roger
Fenton of Crimble Hall* (London, 1975), which
is also short, being one hundred pages of text.
Sadly, both are unfootnoted so the sources
of information are difficult to trace. See also
Valerie Lloyd's valuable and perceptive essays
on Fenton's life and aspects of his work in
Roger Fenton: Photographer of the 1850s (London,
1988). I have substantially relied on these for
the raw data of his life.

8 Correspondence of the period in the posses-
sion of his descendent R.L.M. Rymer-Cooper
suggests that the desirability of purchasing a
lordship of the manor was in part that it con-
veyed underlying mineral rights. Other letters
suggest that the family may have had some
proprietary interest in the Rochdale Canal
around 1810. I am indebted to Mr. Rymer-
Cooper for allowing me to see these family
papers, which give an attractive picture of
Fenton family life at an early period.

9 At the grandfather's death the bulk of his
holdings were divided between his two sons
and one thousand pounds left to each grand-
child upon their coming of age, which Fenton
reached that year. Not all of Fenton's ten half
siblings had yet been born. The Rymer-Cooper
correspondence suggests that Joseph Fenton
gave his relations substantial sums of money
during his lifetime as well.

10 Samuel Jones Loyd (1796–1883), an extremely successful banker, was created first Baron Overstone in 1860 by Queen Victoria; cf. Thomas Humphry Ward, *Men of the Reign* (London, 1885). Significantly, this biographical dictionary of eminent men who had died since Victoria's accession included none of the Fentons.

11 For Delaroche, see Norman D. Ziff, *Paul Delaroche: A Study in Nineteenth-Century French History Painting* (New York & London, 1977).

12 Le Gray's death has long been thought to have occurred in Egypt in 1882 although there is alleged evidence that it may have happened in Villiers-le-Bel, his birthplace, in 1883.

13 Public Record Office, Kew, passport number 719, issued June 28, 1842, for which a fee of two pounds, seven shillings, and sixpence was paid. The possibility exists that Fenton used the passport for another trip, but it seems unlikely because of the persistence of the idea over the years that Fenton studied with Delaroche himself.

14 Ernest Lacan, *Esquisses Photographiques* (Paris, 1856), p. 96. Lacan states that Fenton studied with Delaroche for "plusieurs années" (several years). Lacan knew Fenton more than casually and his word should not be taken lightly.

15 He signs his final letter to her from the Crimea on June 25, 1855: "Thine Roger Fenton." Gernsheim, op. cit., p. 104.

16 I am indebted to Marian Kamlish for the information that the estimated rental of the house "and back premises" was £143 per annum and the rateable value £115; and that in the 1851 census Fenton and his wife lived in the house with their two surviving daughters (their eldest had died the year before), a nurse, and two house servants. The rent was substantially larger than Fenton would have derived from the £1000 he had earlier inherited.

17 Lloyd, op. cit., pp. 7 and 174.

18 Algernon Graves, *The Royal Academy Exhibitors* (London, 1905), vol. 3, p. 98, gives the titles of his three works as: "From Tennyson's ballad of the May Queen 'You must rise, wake and call me early, etc,'" (1849); "The letter to Mamma: What shall we write," (1850); and "There's music . . ." (1851).

19 *Art Journal* (1851), p. 155. At least the picture was reviewed. Many were not.

20 Becoming a barrister at this period entailed some study, but no formal examinations, and attendance at a number of dinners over a period of at least three years. Daniel Pool, *What Jane Austen Ate and Charles Dickens Knew* (New York, 1992), p. 131. As Fenton had been admitted as a member of the Inner Temple in 1839, he had many years over which to eat the requisite meals, which were primarily intended to make the candidate known to the established lawyers.

21 Contemporary sources accord importance, after the fact, to the inclusion of photographs in the exhibition. See for example, *Journal of the Society of Arts* (January 7, 1853), p. 76.

22 Gernsheim asserts that Fenton was making photographs as a member of the Photographic Club in 1847. Lloyd disagrees, believing that Fenton did not begin photographing until later, probably with the securely dated works of February 1852. Hannavy argues for a date somewhere between. Gernsheim, *op. cit.*, p. 5; Lloyd, *op. cit.*, p. 3; and Hannavy, "Roger Fenton and the Waxed Paper Process," in *History of Photography*, vol. 17, no. 3 (Autumn 1993). All three writers seem to have overlooked the statements of two French writers on the subject. The photographer Paul Jeuffrain, writing in *La Lumière* early in 1852, stated "M. R. Fenton, qui depuis quelques mois seulement s'occupe de photographie . . . " (Fenton, who for only a few months has been engaged in photography). Jeuffrain's album in the collection of the S.F.P. contains photographs by Fenton, dated February 1852, made both from waxed paper negatives and collodion on glass negatives. Another writer in *La Lumière*, on May 28, 1853, commented on the very large number of photographs exhibited by Fenton

in London that year: "bien qu'il soit l'un des moins anciens dans la practique de la photographie" (even if he is one of the most recent practioners of photography), clearly indicating that Fenton was still relatively new to photography. Taking these two statements into account, it would seem that Fenton took up photography not much earlier than late 1851, during or just after the time of his visit to the Société Héliographique.

23 Vignoles was later to be a founding member of the Photographic Society.

24 Joseph Cundall published *The Photographic Album* in parts starting in 1852. The first two parts contained six photographs by Fenton. William S. Johnson, *Nineteenth-Century Photography: An Annotated Bibliography* (Boston, 1990), p. 221.

25 I am grateful to Mike Weaver for pointing out to me Fenton's membership in the Arundel Society, an organization dedicated to the circulation of prints of paintings in order to improve popular taste.

26 His portraits of Queen Victoria and her family were among the few photographs that he never exhibited. To control dissemination of these images, the negatives were turned over to the royal family. Some prints, quite different in tone from those that Fenton himself made, were produced from these negatives during the period by Mr. Bembridge, a Windsor photographer who worked extensively for the queen; cf. Frances Dimond and Roger Taylor, *Crown and Camera* (London, 1987), pp. 19–20. The negatives then lay unused in their original wooden boxes in a boiler room in Buckingham Palace until their discovery a few years ago, after which they were transferred to the Royal Archives.

27 Gernsheim, op. cit., pp. 35–104, includes the whole of the correspondence, with minor editing, reproduced from a Fenton family notebook into which the letters were copied after Fenton's return to England. The notebook is now in the collection of the Harry Ransom Humanities Research Center of the University of Texas at Austin.

28 The Raglan sleeve, in occasional use to this day, was invented to compensate for his missing arm.

29 Ulrich Keller has noted these hierarchies, which are also reflected in the prefatory pages of the published portfolios of the work where the patrons are listed in order of social rank.

30 In his letters Fenton refers to the "Rinoco" (his quotation marks). The ship proves to be the steamer *Orinoco*, hired by the Admiralty from the Royal Mail for use as a transport. She left Constantinople about June 28, left Malta on July 1, and arrived Portsmouth July 11, 1855. Liza Verity of the Maritime Information Centre, Greenwich, confirmed my hunch that the ship's name was that of the river and provided details of her itinerary.

31 A passport for James Fenton, either his uncle or perhaps more likely his half brother, was issued on September 4, 1855. Public Records Office, Kew, list of passports issued in 1855. Passports were issued for William Fenton, John Fenton, and another James Fenton in late September, November, and December of that year, but only William, Fenton's half brother, would have arrived in Paris in time to see the Exposition. Linen manufactured by Fenton and Sons was exhibited in the British section of the Exposition, giving members of the family reason to travel.

32 *Catalogue Officiel, Exposition des produits de l'industrie de toutes les nations* (Paris, 1855), p. 193.

33 After his experience of loading a similar carriage onto a ship to be transported to the Crimea, one wonders if he sometimes used the railroads for transporting himself and carriage in Britain. One assumes that he continued to employ a driver, perhaps Sparling.

34 The influence of George Lance (1802–1864) was noted by the critics in 1861. Fenton owned one painting by Lance, a study of peaches and grapes, which was sold with his collection in 1870. Christie's, *Catalogue of the Collection of Ancient and Modern Pictures, Water-Colour Drawings, and Engravings formed by Roger Fenton, Esq., Deceased*, June 13, 1870, lot 103. It is

quite possibly a photograph of this picture by Lance that Fenton exhibited at the Photographic Society of Scotland at the end of 1858.

35 This year also marked the beginning of the cotton famine due to the North's blockade of shipping from the Southern cotton-producing states, which meant that any other of the Fenton enterprises dependent on American cotton must have suffered.

36 See his speech to the Council of the Photographic Society on February 7, 1856: "When we proposed to meet together as a Society, I never thought that we should be more than a little comfortable body of gentlemen, meeting together to ride what I may call our hobby." *Journal of the Photographic Society* (February 21, 1856), p. 301.

37 The house at Potter's Bar stood in generous grounds, affording room for "offices, stabling, cottages, appurtenances, garden and pleasure grounds." Indenture of sale, October 5, 1871, signed by Roger Fenton's brother, James; his half brother, Albert; and his widow. It is significant that Fenton is listed as "gentleman" on the various conveyances by which he acquired the land, while the professions of the sellers are named. I am indebted to Brian Warren, the Honorable Archivist of the Potter's Bar Historical Society, and Colin Osman for information about these transactions. The house was named Mount Grace, after Mrs. Fenton, who was presumably named Grace after the medieval priory of the same name next her family's land in Yorkshire. A school now stands on Fenton's land.

38 In the census of 1871 she and two of her daughters, Eva Katherine and Rose Margaret, are listed as residents at Potter's Bar. Her eldest surviving daughter, Annie Grace, is listed as in Paris, presumably studying painting.

39 Orientalism had an earlier history in Western pictorial art, as exemplified by the work of Gentile Bellini (1429–1507), and of Jean-Etienne Liotard (1702–1789) and Charles-André Van Loo (1705–1765) in the eighteenth century, but its greatest popularity came during the nineteenth century. More current usage of the term is usually derived from the cultural criticism of Edward Said. In his book *Orientalism* (New York, 1979), which is devoted to literature rather than to works in the visual arts, the term has inevitable connotations of cultural condescension, imperialism, incomprehension, and ignorance. Above all it is characterized by its creation of a cultural "other." Reflections of these societal attitudes are present in Orientalist painting and photography.

40 For this earlier work, cf. the introductory chapter of Jean Alzard, *L'Orient et la Peinture Française* (Paris, 1930); Philippe Julian, *The Orientalists* (Oxford, 1977); and Mary Anne Stevens (ed.), *The Orientalists: Delacroix to Matisse*, exh. cat. (London, 1984).

41 Sotheby's sales catalogue, *[...]Books of Prints & Miscellaneous Engravings, The Property of the Late Roger Fenton, Esq.[...]*, August 19, 1870, lot 1072. Bound in half morocco, it brought six shillings and is the only item in the sale that, from the descriptions given, had discernible Orientalist content.

42 The most useful work on Delacroix's painting is Lee Johnson's thorough *The Paintings of Eugène Delacroix: A Critical Catalogue*, 4 vols. (Oxford, 1981, 1986).

43 For Delacroix and Orientalism, see, among others, Stéphane Guégan, *Delacroix et les Orientales* (Paris, 1994).

44 Judging by the disparity of their costumes this may be the photograph that Fenton exhibited under the title *Turk and Arab* in Edinburgh in 1858.

45 For its provenance see Johnson, op. cit., vol. 1, p. 26.

46 This evolution is traced in Margret Stuffmann, *Eugène Delacroix: Themen und Variationen, Arbeiten auf Papier* (Frankfurt, 1987), pp. 152–155. The lineage is slightly differently ordered in Johnson, op. cit., vol. 3, p. 170.

47 Frank Trapp, *Delacroix and the Romantic Image*, exh. cat. (Amherst, 1988), p. 15.

48 For an analysis and history of this painting see Lee Johnson, op. cit., vol. 3, pp. 176–179.

49 Ibid. In Morocco Delacroix wanted to see private dwellings, particularly a harem. Eventually he did, but he had more frequent and liberal access to the homes of Moroccan Jews.

50 Johnson indicates the dating of both these pictures is slightly conjectural, although the dates of their exhibition debuts is secure. For the Mogador painting, ibid., p. 185.

51 Mention should perhaps be made of Delacroix's celebrated *Women of Algiers*, 1834 (Musée du Louvre, Paris), which was shown in the 1855 retrospective and also regularly hung at the Luxembourg. However, except for its wonderful atmospherics, it seems less directly connected to Fenton's images. Delacroix's other North African odalisques do not seem to have been on public view in the 1840s and '50s.

52 Cf. the catalogues of the Paris salons: *Explications des Ouvrages de Peinture, Sculpture, Gravure et Lithographie de Artistes Vivants Exposés au Musée Royal* (Paris, 1843, 1844, 1847 as reprinted New York and London, 1977).

53 For Gleyre's life and work see Charles Clement, *Gleyre: Étude Biographique et Critique* (Paris, 1878).

54 Most of Gleyre's Orientalist work was done as a commission from Charles Lowell, the sponsor of his travel to Greece and Egypt. It was sent to Boston in 1840 after Gleyre had a chance to make copies. See *Charles Gleyre, 1806–1874*, exh. cat. (New York, 1980), p. 104.

55 Marilhat's unexhibited sketches might have been of more interest, cf. exh. cat., *Prosper Marilhat: Peintures, Dessins, Gravure* (Clermont-Ferrand, 1973), particularly one entitled *Musiciens Arabes*, entry 37, p. 19. Marilhat has been little studied. For an entry on his work see Stevens, op. cit., p. 209.

56 For Chassériau, see Marc Sandoz, *Théodore Chassériau: Catalogue raisonée des peintures et estampes* (Paris, 1974).

57 Moulin's name and death date are not firmly fixed. Elizabeth Anne McCauley, *Industrial Madness: Commercial Photography in Paris, 1848–1971* (New Haven, 1994), p. 155, gives his name as Jacques Antoine. As she has been able to fix his birthdate as August 1802 in Montreuil-sur-Mer, she has probably found the correct version of his name, ibid., p. 391, note 27. M. Auer, *Encyclopédie Internationale des Photographes* (Hermance, 1985) n.p., renders it as F. Jacques. Gary Edwards, *International Guide to Nineteenth-Century Photographers* (Boston, 1988), p. 378 lists both an A. M. Moulin, active c. 1860, and F. Jacques, born c. 1800, died after 1868. The index for *La Lumière* (Paris, 1989), p. 70, names Félix, and the Eastman House biographical data base lists Félix Jacques A. and F. Jacques.

58 *La Lumière* (1855), p. 172. McCauley, op. cit., p. 387, note 71, also cites *Revue photographique* (December 5, 1855), p. 20; McCauley also states, p. 391, note 27, that Moulin had acquired the right to print the Crimean pictures, but it seems unlikely that Agnew or Fenton would have allowed the glass negatives to be sent to France for printing.

59 McCauley feels that the work crossed the border from the merely erotic to the outright pornographic, ibid., p. 154 *et seq.*, and notes that Moulin was arrested in 1851 for the production of "obscene subjects."

60 The closest that Fenton came to photographing a nude is a study of a woman seated on a chair and draped in a blanket that leaves one of her breasts uncovered. Although the model is the same woman who appears in many of the Near Eastern pictures, this image should not be considered as one of the series since none of the properties or costumes that characterize the Orientalist pictures are present. In the series photographs there are no chairs and the European carpet was covered over by other rugs in an effort to create an Eastern

nude is in the collection of the Victoria and Albert Museum, London.

61 That connection would have lasted until at least May of 1856, the last issue date given on the mounts of Crimean photographs.

62 Delacroix also took up the theme of North African women and their darker-skinned maids in an etching and a lithograph.

63 As Weston Naef has pointed out, in this directness there is a clear analogy to Manet's *Olympia*, first exhibited nine years later than the date of this photograph. Weston Naef, *Handbook of the Photographs Collection, The J. Paul Getty Museum* (Malibu, 1995).

64 *Poems by Alfred Tennyson* (London, 1860), p. 18, but first published in 1830.

65 At the corner of the only known print of this image there are tiny holes (unlike other prints in the series) indicating that before its inclusion in the "grey" albums it was hung up for viewing. May it then have been a particular favorite of its maker?

66 1858 is a time when some of Rejlander's models in *Two Ways of Life* wear far less.

67 Moulin's example would be followed by other photographers. Gustave de Beaucorps (1825–1906) made pictures of odalisques in Algeria in 1859, of which an example is in the museum at Princeton University. Because of Fenton's reluctance to photograph female nudity, not perhaps surprising in a man of his class and temperament, the less restrained contemporary work of such French photographers as Julien Vallou de Villeneuve (1795–1866) and Jean-Louis-Marie Eugène Durieu (1800–1874) is not really relevant to his production of Orientalist imagery, although he was probably aware of it. In any case, Durieu's studies of nudes made in cooperation with Delacroix were not in general circulation. Vallou's statuesque academic nudes, even when exotically turbaned or draped in pearls, belong more to the realm of classic studies of the female form than to the more specialized world of Near Eastern images.

68 For Roberts's intention to contrast present squalor with past splendor see Kenneth Bendiner's *The Portrayal of the Middle East in British Painting, 1835–1860*, unpublished Ph.D. diss., Columbia University, 1979, p. 108 *et seq.*

69 Although the sale of Fenton's books, folios, and albums of prints and engravings included a large variety of kinds of work, ranging from Landseer to Rembrandt, no work by Roberts was listed. Sale cat., Sotheby's, London, August 19, 1870, lots 1070–1107. Individual lots contained as many as 301 works.

70 Lear was in Cairo in late 1853 and early 1854 with Fenton's acquaintance Thomas Seddon and with Holman Hunt, but no more direct connection has been found. Cf. Allen Staley, *The Pre-Raphaelite Landscape* (Oxford, 1973), p. 98 *et seq.*, and John P. Seddon, *Memoir and Letters of the Late Thomas Seddon* (London, 1858), p. 55. No work by Lear figures in the sale of Fenton's collections in 1870.

71 Julie Lawson, "The Painter's Vision," in *Visions of the Ottoman Empire*, exh. cat. (Edinburgh, 1994), p. 33.

72 As an example of an English painter claiming fresh territory, note Frederick Goodall's statement in 1858 in Egypt: ". . . [I] felt absolutely convinced that the people had never been painted, that practically I was on virgin soil, with a free hand." Frederick Goodall, *The Reminiscences of Frederick Goodall, R.A.* (London, 1902), p. 67.

73 The Old Society was later to become the Royal Society of Painters in Water Colours, whereas the New Society became The Royal Institute of Painters in Water Colours.

74 Algernon Graves, *The Royal Academy of Arts: A Complete Dictionary of Contributors* (London, 1906), vol. 7, p. 70. Seddon's picture *An Arab Sheikh and Tents in the Egyptian Desert* was noted to have been "painted on the spot," in the same way Julia Margaret Cameron twenty years later would note that her photographs were "from nature." Little has been written about Seddon except for a chapter in Allen Staley, op. cit.

75 The Seddon drawing that Fenton owned was entitled *Music's Power*, lot 78, in the Christie's sale of June 13, 1870.

76 Algernon Graves, *The British Institution, 1806–1867: A Complete Dictionary of Contributors* (Bath, 1969), p. 332.

77 Sale cat., Sotheby's, London, June 25, 1982, lot 165.

78 Egg was later to copy Fenton's Crimean war photograph *The Council of War* as a painting. Gernsheim, op. cit., p. 30. No other connection between Egg and Fenton has come to light.

79 William Holman Hunt, *Pre-Raphaelitism and the Pre-Raphaelite Brotherhood* (London, 1905), vol. 2, p. 82. The sketch is reproduced at p. 79.

80 Both the panther skin and wreath of grapes which the prince wears are traditional attributes of autumn. Cf. Ardern Holt, *Fancy Dresses Described or What to Wear at Fancy Balls* (London, 1896), p. 17.

81 *Queen Victoria's Journal*, May 24, 1854, as quoted in Frances Dimond and Roger Taylor, op. cit., p. 51.

82 Sale cat., Christie's, London, June 13, 1870, lots 88–89, which were acquired by Agnew. Most painters in Fenton's collection were represented by single examples. An exception was the obscure Pierre Joseph Dedreux-Dorcy (1810–1874) by whom Fenton owned either three or four portraits, apparently all of children, and one copy after Velasquez.

83 The four photographs by Fenton that Haag acquired survived as a group to be sold at auction in the early 1980s. Two other works in the same lot were the view made in Dillon's studio, mentioned above, and a portrait by William Grundy of Haag in Eastern costume, seated on an Oriental rug, pen in hand, and surrounded by paraphernalia of the variety Fenton used to embellish his photographs. The Grundy study of Haag in Eastern costume is illustrated in the sale catalogue, Sotheby's, London, June 25, 1982, lot 167.

84 Fenton acquired single works from the following members of the Old Water Colour Society: William Callow, Anthony Vandyke Copley Fielding, David Cox, Jr., Maria Harrison, James Holland, Samuel Phillips Jackson, Frederick or Joseph Nash, and Samuel Prout. He purchased two by Walter Goodall and three by Octavius Oakley. Christie's sales catalogue, June 13, 1870. He may, of course, have owned more works than were sold in 1870.

85 Minutes of the Council of the Photographic Society, particularly those for November 3, 1853; December 7, 1854; and September 27, 1855. These minutes are in the collection of the Royal Photographic Society, Bath.

86 Goodall later stated that his sole object in first visiting Egypt was to paint Scriptural subjects. Goodall, op. cit., p. 97. In this he reflects the belief of the time that the appearance of the Islamic world continued without change that of the Biblical world.

87 M. Phipps-Jackson, "Cairo in London: Carl Haag's Studio," *Art Journal*, no. 45 (1883), p. 71.

88 Gernsheim, op. cit., p. 50; Fenton's letter of April 9, 1855 to William Agnew. Fenton did not make a portrait of Goodall as he did of another war artist, William Simpson, so the contact may have been fleeting.

89 Their titles, as listed in the Christie's sale catalogue of June 13, 1870, were *Nature's Mirror* (lot 88), and *The Beehive* (lot 87).

90 This image is one of four variants of women carrying water jugs on their heads, all of which employ the same model with the same headcloth and jug. In two she wears an open-throated dark robe with a medallion on a cord barely visible underneath her robe and a necklace of coins across her forehead and has a triangular simulated tattoo on her chin. Fenton included the word Nubian in the titles of these two. In the other two, which he did not title with the word Nubian, she wears a white robe, has no medallion, no necklace of coins, and no tattoo. Over the years there has been considerable confusion as to these titles, with

the word Nubian often misapplied to photographs that Fenton titled elsewise.

91 See for example, Gernsheim, op. cit., p. 75, where Fenton describes making a sketch, in color, of the valley of Inkerman.

92 Charles Holmes, *The Old Water-Colour Society, 1804–1904* (London, 1905), p. iv. For an account of Price's life until 1891, see John Lewis Roget, *A History of the Old Water-Colour Society* (London, 1891), p. 255 *et seq.* Lake Price was admitted to the Society in 1837, and from then until 1852 exhibited forty-two works in their exhibitions.

93 *Catalogue of the Art Treasures of the United Kingdom*, exh. cat. (London, 1857). Lake Price exhibited three watercolors and twenty-five photographs with a variety of subjects, including portraits, tableaux, still life, allegories, and landscape. Fenton exhibited eight photographs: one architectural study and seven landscapes.

94 The Lake Price album is in the Gernsheim collection at the Harry Ransom Humanities Research Center of the University of Texas at Austin.

95 Because of his acquisitions of the work of members of the New Society of Painters in Water Colours he can also safely be assumed to have also attended their exhibitions. The sale of his collection in 1870 included single works by Henry Bright, David Hall McKewan, and Thomas Sewell Robins; two by John Henry Mole; three by Mrs. Mary Margetts; and four by Thomas Shotter Boys, all members of that organization, cf. H.M. Cundall, *A History of British Water Colour Painting* (London, 1908), pp. 165–175. Although Fenton acquired works from a smaller number of members of the New Society, he bought from them in slightly larger quantities than from the members of the Old Water Colour Society, so the total of works from the New and Old Societies is about the same.

96 *Art Journal* (1858), p. 43. It was published with two other woodcuts in an extensive laudatory article on Lewis.

97 Martin Hardie, *Water-colour Painting in Britain* (London, 1968), vol. 3, *The Victorian Period*, p. 59.

98 Ruskin wrote the year before about Lewis's work *Encampment in the Desert*, "I have no hesitation in ranking it amongst the most wonderful pictures in the world; nor do I believe that since the death of Paul Veronese anything has been painted comparable to it in its own way." John Ruskin, *The Works of John Ruskin* (London, 1904), vol. 14, pp. 73–78, as quoted in Michael Lewis, *John Frederick Lewis* (Leigh-on-Sea, 1978). Ruskin thought Lewis to have been more Pre-Raphaelitic than the Pre-Raphaelites, whose style, he said, Lewis anticipated before their existence and surpassed during their heyday. By the end of the decade Ruskin had tired of Lewis's immediate subject matter, exhorting him to move on to more than carpets and camels. John Ruskin, *Mr. Ruskin's Notes on Some of the Principal Pictures* (London, 1859), p. 14.

99 *Art Journal* (1857), p. 178.

100 *The Corsair Chief* by G. Harris, *His Highness Toussoun Pasha* by A. Hert, and two portraits in Oriental costume by Mrs. Carpenter, were all reviewed by the *Art Journal* (1858), pp. 161–172. Ruskin noted that Dillon exhibited a *Sunset on the Nile* and *Emigrants on the Nile*; Ruskin, *Mr. Ruskin's Notes (etc.)*, p. 13. There may have been, in fact, other Orientalist pictures which were not reviewed.

101 *Catalogue of the Art Treasures of the United Kingdom* (London, 1857). Fenton also owned a watercolor by Bonington, but of a wholly different character, a study of Queen Elizabeth I.

102 Linda Nochlin, "The Imaginary Orient," *Art in America* (May, 1983), p. 121.

103 Bendiner, op. cit., pp. 88–90.

104 Ibid., p. 198, distinguishes Lewis's work from those of his predecessors and contemporaries in its specific distance from Western social conventions, despite its respect for Western proprieties.

105 Cf. the review of the Photographic Society

exhibition of 1859 in the *Athenaeum* (January 15, 1859), p. 86, where the props are noted as particularly Eastern in effect.

106 The standard account of Frith's life is Julia Van Haaften's introduction to *Egypt and the Holy Land in Historic Photographs* (New York, 1980).

107 *Art Journal* (April 1, 1858), p. 121.

108 *Athenaeum* (March 20, 1858), p. 371.

109 In correspondence Doug Nickel was kind enough to point out that this meeting occurred.

110 A charming oddity in Fenton's ordinary presentation of himself for the camera in England was that he posed more than once in a French kepi that had apparently been given to him in the Crimea.

111 The variants can be found in copies of *Egypt and Palestine* (1859), in the collection of the J. Paul Getty Museum and that of the Royal Photographic Society, and in *Egypt, Sinai, and Palestine* (1863), also at the J. Paul Getty Museum.

112 It has been suggested that Frith's costume is what he wore when in the field although not in the somewhat Europeanized cities of Cairo or Jerusalem, but this tight-fitting blouse and sash with Turkish carpet slippers seems to be unlikely garb for use anywhere except in a city and even then to be unsuited for the real physical work of making photographs. Cf. the comments of Jon E. Manchip White in Van Haaften, op. cit.

113 An earlier example of a photographic self-portrait in Oriental costume is a daguerreotype of ca. 1845 reproduced as by Collard in Nissan Perez, *Focus East, Early Photography in the Near East* (New York, 1988), p. 33. The first name of the maker is not supplied, but it presumably is not the photographer of bridges, canals, and railroads Hippolyte Auguste Collard (1811–after 1887), as his earliest work dates from the 1850s. Cf. McCauley, op. cit., pp. 202–203. A slightly later example is Gustave de Beaucorps's self-portrait of about 1859.

114 A variant is reproduced in *Popular Photography*, vol. 24, no. 3, (March 1949), p. 46.

115 A nargileh is the Near Eastern version of the Indian hookah and was often used by Fenton as a studio prop.

116 Goodall, op. cit., pg. 70. Although this reference to native dress is Eurocentric, the term is not used here pejoratively as it usually was in the nineteenth century. Holman Hunt adopted a version of local costume to some extent, as did Flaubert, Sir Richard Burton, and Edward Lane. For an interesting division of these Orientalizing self-portraits into "warrior" and "despot" types, see David Bates, "The Occidental Tourist: Photography and Colonizing Vision," *Afterimage*, vol. 20, no. 1, (Summer 1992). By Bates's analysis, Fenton's self-portrait in Zouave costume would partake of both. He chalks up the existence of such portraits to mimicry and desire.

117 The people are, of course, posing—the exposures of the 1850s, even outdoors, required that people remain motionless for some seconds, a minimum of three according to Fenton's Crimean account.

118 These studies are comparable to those of *petit metiers* that Eugène Atget would produce in Paris about 1900.

119 Lacan, op. cit., p. 105.

120 Ibid., p. 172. Lacan contrasts the rough comfort of Fenton's borrowed tent in the Crimea with Fenton's "jolie maison" (pretty house) in Regent's Park.

121 Beaumont Newhall's research notes in the Special Collections at the Getty Center for the History of Art and the Humanities include a citation for Robertson: *Photographic Views of the Antiquities of Athens, Corinth, Egina* [sic], etc., which was once part of the Marshall collection. Newhall may have seen it at the sale of that collection in 1952.

122 I am indebted to Roger Taylor for pointing out that this photographic tour occurred and that Robertson participated in it.

123 The spelling of his name is subject to considerable variation. Gernsheim gives it as Carol Pop de Szathmary and Carl Baptist de Szathmary. The catalogue of the 1859 exhibition of the Société Française de la Photographie renders it as Szatthmari and an auction catalogue of the 1980s as Carol de Szathmari. I have settled on the name as printed on the mounts of a group of photographic costume studies in an album in the collection of André Jammes, Paris.

124 Grundy was not alone in exhibiting exotic subjects in 1857. As Roger Taylor pointed out in correspondence, Francis Bedford, Fenton's rival in landscape photography, at the 1857 exhibition of the Photographic Society showed two pictures in one frame, entitled *Group, Circassian Costume* and *Group, Arab Costume*. Surviving prints of these images are presently unknown to this author.

125 There are five densely packed albums of single halves of stereo views by Grundy in the Hulton-Deutsch Collection, London, but containing such a wide variety of material as to make it unlikely that all of these images can be by one hand.

126 In the other three Fenton images of liquids being poured, in two cases the recipient is a man and the pourer a servant or a street vendor, and the drinks, judging by the vessels being used, are respectively, coffee and water. Both are in the collection of Michael Wilson. In the third the recipient is a seated woman and the dispenser of water or perhaps oil a standing man.

127 Bonington titled a picture *The Chibouk* and Byron refers more than once in *Don Juan* to Turks impassively smoking amid disaster.

128 *Athenaeum* (May 29, 1858), p. 693. Both the Calenderer's brother and Alnaschar are characters in the *Arabian Nights*, that collection of interwoven tales, the extended narrative of which is longer than Ariadne's thread.

129 Grundy's photographs were seen by this reviewer as superior to Lewis's watercolors except in respect to their lack of color and "honour." This last term seems to be a reference to the homely, mundane subject matter of the photographs by comparison to the more genteel worlds that Lewis depicts. This caste system of subjects relates to distinctions between high and low art.

130 Fenton's studies of works of art in the British Museum sold for less, at six shillings. Frith's large-scale Egyptian views sold for fifteen shillings. The most expensive picture was Rejlander's *Two Ways of Life* at two hundred and ten shillings. Admission was a shilling and the catalogue six pence. *Exhibition of Photographs and Daguerreotypes at the South Kensington Museum, Fifth Year* (London, 1858).

131 *Art Journal* (April 1, 1858), p. 121, "Mr. Fenton, as usual, gives us many well-selected scenes, treated with his artistic feeling, and full of those marvelous details which have ever been the prominent charm of a photograph."

132 *Photographic Journal* (May 21, 1858), p. 208.

133 *La Lumière* (January 1858), p. 50.

134 *Photographic Journal* (April 21, 1868), pp. 190–96, reporting on a meeting of the Photographic Society on April 6, 1858.

135 Ibid.

136 At some periods genre was placed even below still life; at no time were either considered high art.

137 For an example of a systematic exposition of principles to be applied to the arts dating from this period, see André Félibien, *L'Idée du peintre parfait* (London, 1707), Slatkine reprint, (Geneva, 1970). See also Sir Joshua Reynolds, *Discourses on Art* (New Haven, 1975). In Fenton's day, the decline of this theory was imminent.

138 Mercifully, a more thorough consideration of the relation of the codification of types of painting to social gradations of rank is beyond the scope of this essay. John Welch first suggested the provocative idea that Fenton aspired to a class to which he did not belong. This writer looks forward to the completion of his work on Fenton.

139 Sale cat., Sotheby's, London, August 19, 1870. Fenton owned a large variety and number of prints and engravings, including work by Hogarth, Piranesi, Claude, Teniers, van Leyden, Hollar, and Rembrandt.

140 Sale cat., Christie's, London, June 13, 1870, pp. 3–4. The engravings were executed by Abraham Raimbach (1776–1843). For examples of Wilkie's work, see *Sir David Wilkie of Scotland*, exh. cat. (Raleigh, North Carolina, 1987).

141 *The Wilkie Gallery: A Selection of the Best Pictures of the Late Sir David Wilkie, R. A. Including his Spanish and Oriental Sketches* (London, c. 1848). Cited in ibid., p. 374.

142 This is, in fact, the second in the series of four. All four are reproduced in Dimond and Taylor, op. cit., p. 133.

143 Gernsheim, op. cit., p. 35.

144 If Fenton went, in fact, to Italy on his earlier trip, he apparently did not go to Naples, as in a Crimean letter he says that the beautiful situation of the town of Kertch reminds him of "the pictures of Naples" rather than, more simply, Naples itself. Ibid., p. 82.

145 Ibid., p. 37.

146 Edward Said, op. cit., p. 164, describes this translation as uninspired and the commentaries as typifying Lane's dispassionate Orientalism. It is also bowdlerized so as not to offend Victorian sensibilities. Richard Burton's more frank version was many years in the future.

147 Gernsheim, op. cit., pp. 39–40.

148 Ibid., pp. 40–41.

149 Ibid.

150 Ibid., p. 42.

151 Two years later, in 1857, the picturesque uniforms and uninhibited playfulness of French Zouaves were to be a frequent subject for Fenton's great contemporary Gustave Le Gray at the camp at Chalons. It is not accidental that Fenton chose to pose in a Zouave uniform for his Crimean self-portrait.

152 *Athenaeum* (September 29, 1855). The statement reeks of what Said would consider quintessential European Orientalism in its simplistic distortions of Moslem theology.

153 Gernsheim, op. cit., p. 58.

154 Gernsheim, op. cit., p. 72. Fenton refers to the other attendant as the pasha's Nubian slave.

155 Roger Taylor pointed out in correspondence that the picture may not be by Fenton. However, its dimensions, color, mount, and format are consistent with his work, and it is titled "Turkish Scribe" in his hand. In any case, it belonged to him, and entered the collection of the Royal Photographic Society in the 1930s with other work by him that came from the Fenton family. Even if the picture was not made by Fenton, his ownership of it is token of his interest in the subject.

156 Said, op. cit., p. 176.

157 For Giovanni Bellini's life and work see Jurg Meyer Zur Capellen, *Gentile Bellini* (Stuttgart, 1985).

158 Sold at auction in the late 1970s, these portraits have now dropped from view.

159 Roger Taylor kindly supplied me with a list of Fenton titles shown in this exhibition and for that in London in 1859.

160 The public exhibition of a portion of Fenton's suite of Turkish photographs was not the only manifestation of Orientalism in 1859 in Britain. That year Edward FitzGerald's translation from the Persian of *The Rubáiyát of Omar Khayyám* appeared.

161 When Fenton again exhibited a print of this image in Scotland, at the Aberdeen meeting of the British Association in 1859, in the catalogue the bayadère reverted to being a dancing girl and the pasha became a pacha. Larry Schaaf kindly provided me with a copy of the catalogue of that exhibition.

162 Clearly the woman is not actually a Nubian, and is only called that because of her water-carrying pose and the simulated tattoo on her chin. Fenton seems to have used the word